PRINCETON FOOTBALL

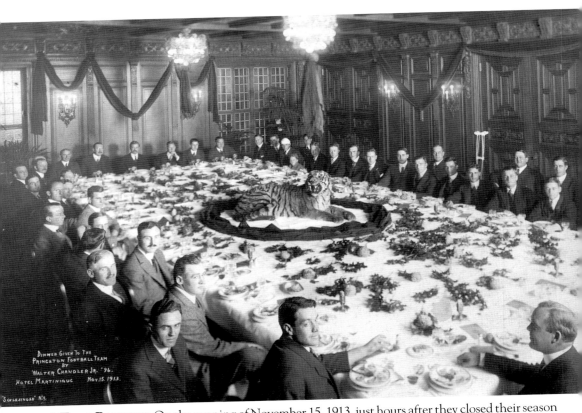

A TIGER BANQUET. On the evening of November 15, 1913, just hours after they closed their season with a 3-3 tie against Yale, the Princeton Tigers held their team banquet at New York's Hotel Martinique. It was the last official function for captain Hobey Baker '14, one of Princeton's true legends, who went out a hero by kicking the game-tying field goal in his final game. Although the game was several years removed from the great controversies over violence that almost destroyed the sport, the continued roughness of football is evidenced by the bandages and crutches visible in this scene. Princeton president John Grier Hibben acted as toastmaster at the banquet, followed by a string of Tiger greats from years gone by: Snake Ames, Beef Wheeler, Biffy Lea, Big Bill Edwards, and Eddie Hart. Under the stuffed tiger's serene gaze, they relaxed, swapped stories, and celebrated their common bond. (Courtesy of the Princeton University Archives.)

On the front cover: Dick Kazmaier '52 was the last Ivy League player to win the Heisman Trophy, and his No. 42 jersey, which was also worn by basketball star Bill Bradley '65, was retired by the university in 2008. (Courtesy of the Princeton University Archives.)

On the back cover: Princeton Stadium, which opened in 1998, stands on the site of Palmer Stadium, which was the Tigers' home from 1914 until 1996. (Courtesy of the Princeton University Athletic Department.)

Cover background: The 1896 team won the national championship with a stellar record of 10-0-1. (Courtesy of the Princeton University Archives.)

PRINCETON FOOTBALL

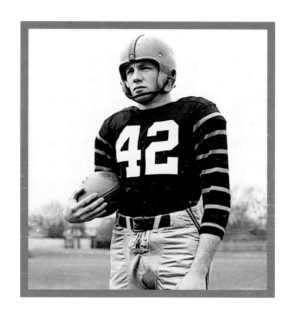

Mark F. Bernstein

ARCADIA
PUBLISHING

Published by Arcadia Publishing
Charleston SC, Chicago IL, Portsmouth NH, San Francisco CA

Printed in the United States of America

Library of Congress Control Number: 2009921323

For all general information contact Arcadia Publishing at:
Telephone 843-853-2070
Fax 843-853-0044
E-mail sales@arcadiapublishing.com
For customer service and orders:
Toll-Free 1-888-313-2665

Visit us on the Internet at www.arcadiapublishing.com

To Susie, with love and thanks for everything

CONTENTS

Acknowledgments

6

Introduction

7

1. The Early Years: 1869–1899

9

2. This Side of Paradise: 1900–1920

31

3. Between the Wars: 1921–1940

47

4. Caldwell and Heisman: 1941–1957

71

5. Ivy Glory: 1958–1982

95

6. Recent Years: 1983–2008

113

ACKNOWLEDGMENTS

The organization now known as the Princeton Football Association (PFA) was formed by some of the men who played on the 1869 team in the first intercollegiate game, so it is true that Princeton has been promoting football as long as it has been playing it. The PFA, under the leadership of Frank Vuono '78 and Anthony DiTommaso '86, has also promoted this book, and for that I wish to express my thanks. Many thanks to the staff of the Seeley G. Mudd Manuscript Library at Princeton University, especially Dan Linke, Amanda Hawk, and John DeLooper. Thanks, too, to Jerry Price, Craig Sachson, and the Princeton University Athletic Department, as well to AnnaLee Pauls of the Rare Books and Special Collections Department of the Princeton University Library. Stanislaw Maliszewski provided invaluable support, suggestions, and historical insight. Redmond Finney, Constance McGillicuddy, and Asa Bushnell III all loaned photographs. Marisa Weisbaum of the William Penn Charter School provided editorial assistance. Chestnut Hill Coffee Company provided a warm and congenial place in which to write much of this book. Thanks, finally, to Rebecca, without whom none of my books would ever be written. Frances and Taylor remain very enthusiastic cheerleaders.

Unless otherwise noted, all images come from the Princeton University Archives at the Seeley G. Mudd Library. As indicated, images also appear courtesy of the Princeton University Athletic Department (PUAD). Where appropriate, specific photographic credit is noted.

INTRODUCTION

Every Princeton football fan knows about Dick Kazmaier '52. He was one of the greatest players ever to wear the orange and black, was the last Ivy League player and the only Princetonian to win the Heisman Trophy, and was named the Athlete of the Year by the Associated Press in 1951, beating out such legends as Stan Musial, Ben Hogan, and Otto Graham. In 2008, the university retired Kazmaier's No. 42—not just in football, but in all sports (another Princeton icon, basketball star Bill Bradley, also wore it). It is the only jersey number Princeton has ever retired.

Kazmaier was drafted by the Chicago Bears, who were then led by George Halas, a legend in his own right. But Kazmaier never played in the National Football League; in fact, he never even went to training camp. Instead, he enrolled in Harvard Business School. "I could probably sign a pro contract and make a lot of quick cash," he told the *New York Times*. "That's not for me. . . . I'm going to get some more schooling." The decision turned out pretty well for Kazmaier, who went on to become a successful businessman and president of the National Football Foundation.

Half a century later, another Princeton back, Cameron Atkinson '03, faced a similar decision about his future. He graduated as Princeton's third-leading rusher and accounted for 3,939 all-purpose yards during his career. Possibly the fastest player Princeton has ever produced, Atkinson ripped off 233 yards in a game against Dartmouth during his senior season, not much behind the 262 yards Kazmaier had amassed against Brown in 1951.

Atkinson was also an Academic All-American, only the seventh Tiger to earn that distinction. He had chosen to major in chemistry (not traditionally a popular major for football players) and had tutored his teammates in math. Like Kazmaier, Atkinson also passed up a chance to try out for the NFL and chose instead to enroll in Vanderbilt's medical school, where he is currently a resident in orthopedics. Ironically, when Atkinson arrived in Nashville, one of the first people he heard from was Josh Billings '33, who had been captain of the 1932 Princeton team and was a longtime member of the Vanderbilt medical school faculty.

Then, too, take Jonathan Edwards Schultheis '83, an All-Ivy guard and team captain in 1982. The Philadelphia Eagles, who were then two years removed from a Super Bowl appearance, selected Schultheis in the 1983 NFL draft and offered him a contract, but, as might be expected of someone named Jonathan Edwards Schultheis, he had his heart set on attending seminary instead and did not believe in playing football on the Sabbath. Schultheis is now an ordained minister and teaches at a prep school in New Jersey.

The point is not that Princeton players think themselves too good for the NFL. Several Tigers have had proud professional careers. Bob Holly '82 and Jason Garrett '89 both won Super Bowl

rings. Zak Keasey '05 started for the San Francisco 49ers and Charlie Gogolak '66 was drafted in the first round by the Washington Redskins. There have been many others. But they had a breadth of talent and opportunity that enabled them to excel off the field, as well as on it. Charlie Gogolak, by the way, earned a law degree from George Washington University while playing for the Redskins.

If one tries to identify what makes Princeton football special, it might be that extra dimension. The examples are nearly endless. George Shultz '42 is one of them. He had been penciled in as a starter for his senior year but injured his knee in practice and ended up helping to coach the freshmen instead. That instilled a love of teaching that led him to the faculty at MIT and Stanford University and a long, distinguished career in government. There is also Bill Roper '02, who coached the Tigers to four undefeated seasons while holding down a job as a Philadelphia city councilman. Or Stas Maliszewski '66, who turned down the University of Notre Dame to become a consensus All-American linebacker at Princeton while majoring in philosophy and writing his thesis on the nature of God in the works of David Hume and Immanuel Kant.

The Tigers are hard to pigeonhole and their influence has pervaded every aspect of the game, from its earliest days to today. Maybe it is fitting that Princeton is the oldest college football team, with a tradition dating back to 1869, yet they play their games in the Ivy League's newest stadium. When they moved into that new stadium in 1998, they also resurrected the old helmet design that Fritz Crisler introduced at Princeton in the 1930s, before taking it with him to the University of Michigan.

This book attempts to capture some of the traditions of Princeton football and give at least a hint of that extra dimension. Many of the players and coaches will be familiar to the casual fan but there are many others who were famous in their day but now are largely forgotten. They deserve to be remembered too.

Princeton football is more than what has taken place on the gridiron at Palmer Stadium or the new Princeton Stadium. It is also a pregame tailgate party in an eating club parking lot, a locomotive cheer and a rousing chorus of "Going Back to Nassau Hall," a sometimes scruffy tiger mascot cavorting alongside an equally scruffy marching band, and, every once in a while, a championship bonfire blazing on Cannon Green.

For 140 years, the men who have played and coached Princeton football have thrilled their many fans. Theirs is a long and proud history, boasting more national championships (28) than any other school. On an increasingly diverse and busy campus, no other activity can induce 20,000 people to put on their school colors and cheer together for a few hours. Princeton football will surely continue to do that for decades more to come. And we will surely be hearing more from those gridiron stars after they have left the field.

THE EARLY YEARS

1869–1899

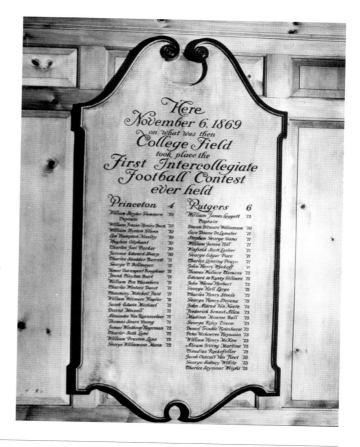

FIRST INTERCOLLEGIATE FOOTBALL GAME. Princeton and Rutgers first met in New Brunswick on Saturday, November 6, 1869. Rutgers won the game, the rules of which were very similar to those of soccer, by a score of 6-4, but Princeton earned its first victory in a rematch a week later. This historical marker, in the Rutgers gymnasium, marks the site of the first-ever game. (PUAD.)

WILLIAM GUMMERE '70. William Gummere was Princeton's captain for its first games against Rutgers but earned fame on other fields, as well. An outfielder on the Princeton baseball team, Gummere is credited with being the first person to steal second base by sliding feet first. He later served as chief justice of the New Jersey Supreme Court.

JACOB MICHAEL '71. Jacob Michael was a burly junior known as "Big Mike." When Princeton fell behind in its first game against Rutgers, captain Gummere instructed Michael to break up the opposing line. Michael did as he was told and, according to one historian's account, "scattered the players like a bursting bundle of sticks." Later in the game, he scored Princeton's first-ever points.

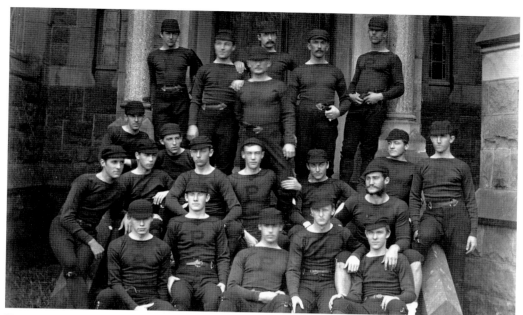

THE 1876 TEAM. During the 1876 season, Princeton met Yale in Hoboken wearing black uniforms adorned with an orange *P*. That game, or the Penn game a few weeks earlier, is believed to be the first time they wore what are now their official colors. Later in the fall, representatives from Princeton, Harvard, Yale, and Columbia met to hammer out a uniform set of rules for football.

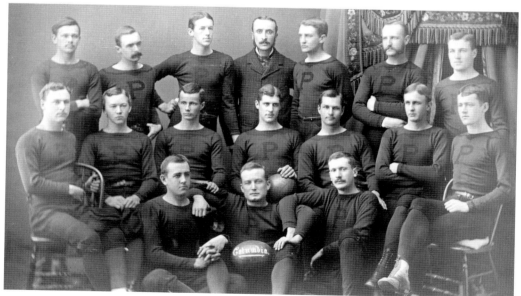

THE 1877 TEAM. Even though Princeton lost their first-ever game against Harvard under the new rules and managed a scoreless tie against Yale, a convincing win over Columbia, the only other member of the Intercollegiate Football Association, enabled them to claim another national championship. The game still had not completely changed toward rugby, as is evidenced by the round ball.

PRINCETON FOOTBALL

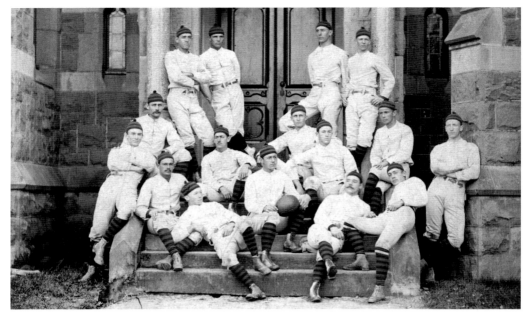

THE 1879 TEAM. By the end of the game's first decade, the ball had changed and so had the uniforms. A victory over Harvard also included the first-ever use of blocking by the offensive line. Princeton did not lose a game that year and claimed the national championship.

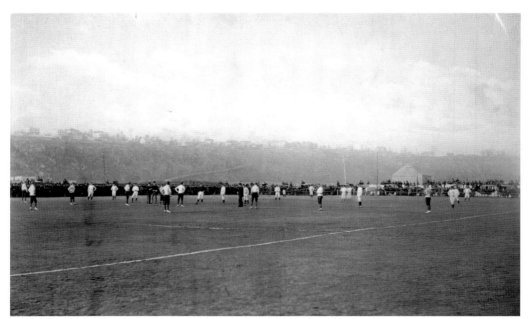

THE LAST GAME OF 15 MEN A SIDE. The 1879 Yale game, shown here, was played on the St. George's Cricket Grounds in Hoboken and ended in a 0-0 tie. That winter, Yale's Walter Camp introduced a rule reducing the size of a team from 15 to 11, which allowed for more open field running. Princeton played most of its big "home" games in Hoboken between 1877 and 1887.

THE EARLY YEARS: 1869–1899

LEDRU SMOCK '79. Ledru Smock's contribution to Princeton football was sartorial. He designed sleeveless canvas jackets that laced up the front and became known as "smocks." Because tackling below the waist was still illegal, the snug fitting jackets made players who wore them difficult to tackle, even more so when greased with tallow, a practice soon outlawed. Smocks remained a standard part of the football uniform until the early 1900s.

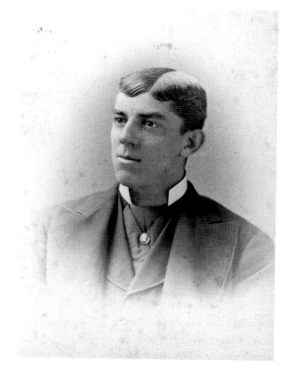

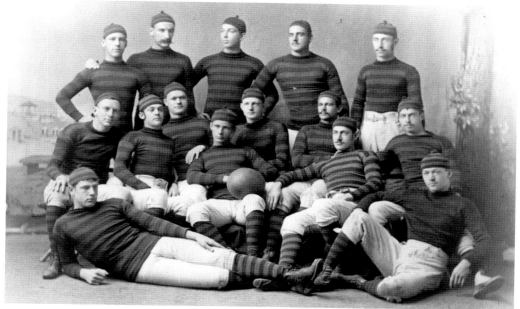

THE 1880 TEAM. The 1880 team claimed a controversial national championship. Princeton took 11 safeties (which did not yet count as points for the other side) in its 0-0 tie against Yale, but the rules committee refused to award the title to either team. This was also the first year in which orange stripes were added to the jerseys, a feature of Tiger uniforms to this day.

ALEXANDER MOFFAT '84. The diminutive Alexander Moffat, who was known as "Teeny-bits," is credited with inventing both the drop kick and the spiral punt. As Princeton's captain in 1883, he booted 32 field goals in 15 games, including five during a 26-7 victory over Harvard: two drop kicks with each foot and one more from placement. Moffat was elected to the College Football Hall of Fame.

JERRY HAXALL '83. John "Jerry" Triplett Haxall, a 158-pound tackle, discovered that by kicking the ball at its end, rather than in the middle, it traveled farther. In 1882, he put this discovery to the test, kicking a 65-yard field goal in a loss to Yale. The kick would remain a collegiate record until 1977 and is still longer than the professional record of 63 yards.

THE EARLY YEARS: 1869–1899

HENRY LAMAR '86. Yale was protecting a lead in 1885 when they decided to punt. Henry "Tillie" Lamar, a master of the stiff arm, fielded the kick on his own 20-yard line and flashed the length of the field for a touchdown that gave Princeton its only victory over the Elis from 1879 to 1888. It has been called one of the most celebrated plays of the 19th century.

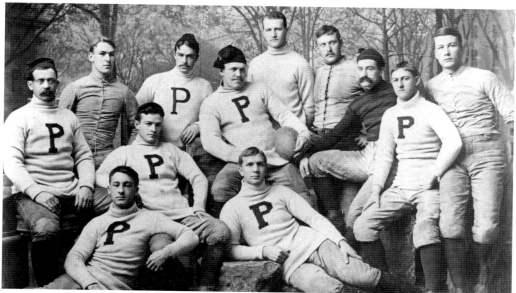

THE 1888 TEAM. The 1888 squad outscored their opponents 609-16, but lost their last game, and the national championship, to Yale. They were led by Hector Cowan '88; Knowlton Ames '90, nicknamed "Snake" because of his shifty running style; Monte Cash '91; and Ben "Sport" Donnelly '93, whom Yale's Pudge Heffelfinger called the only man who "could slug you and at the same time keep his eye on the ball."

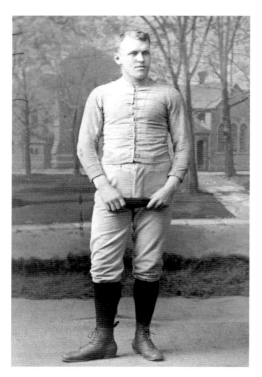

HECTOR COWAN '88. Although he had already graduated from college, Hector Cowan enrolled in the Princeton Theological Seminary so he could play another season. A sturdy lineman, he could nevertheless run the 100-yard dash in 11 seconds and his harshest profanity was said to be, "Oh sugar!" He was later voted to the all-time All-America team and was elected a charter member of the College Football Hall of Fame.

LUTHER PRICE '88. Early football was shockingly violent. When Walter Camp conducted an investigation of rough play in 1893, he contacted former players. Luther Price, a halfback, wrote to Camp that he had been forced to leave the 1887 Princeton-Harvard game (a 12-0 Crimson victory) "due to sheer weakness and loss of blood." That game, he later remarked, "was pretty near butchery."

Pach Bro's

841 B'way. N. Y.

WILLIAM GEORGE '89. In the days before strict eligibility standards were enforced, William "Pop" George played four years for Princeton but was permitted to enroll in classes as a graduate student before the Harvard and Yale games in 1889; he again anchored the Tiger line, helping them to a national championship—at the age of 28. Walter Camp named George to the first-ever All-America team that season.

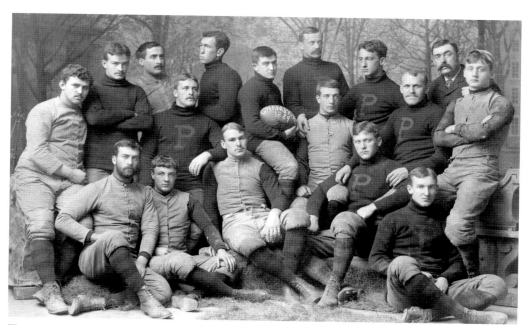

THE 1889 TEAM. Not only did the Tigers go undefeated, they won every game by at least 10 points. Quarterback Edgar Allen Poe '91 (holding ball), a grand-nephew of the poet, was named to the first All-America team that year. "Is he related to the great Edgar Allen Poe?" a young woman asked before the Yale game. "He *is* the great Edgar Allen Poe," her escort replied.

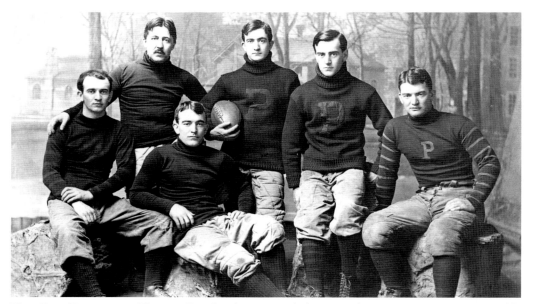

THE POE BROTHERS. The six Poe brothers provided some of Princeton's most memorable players during the late 19th and early 20th centuries. They are, from left to right, Arthur '00, Samuel '84 (a lacrosse All-American, as well), Neilsen '97 (who for years afterwards coached the Tiger scrubs), Edgar Allen '91, Gresham '02, and John '95.

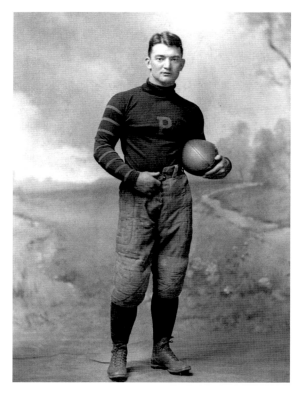

JOHN POE '95. Johnny Prentiss Poe's promising football career was cut short but he became a Princeton icon nonetheless. A soldier of fortune, he traveled the world in search of military glory, which he found during World War I as a member of the Black Watch. He was killed in battle and the Poe Trophy, named in his honor, is awarded to Princeton's most valuable player. It was later renamed the Poe-Kazmaier Trophy.

JESSE RIGGS '92. Jesse Riggs was a two-time All-American at guard in 1890 and 1891. During those two seasons, Princeton compiled a record of 23-2-1 and the offense Riggs helped lead outscored their opponents, 869-77. As was typical in the era before full-time paid coaches, Riggs returned to help coach the team in 1892.

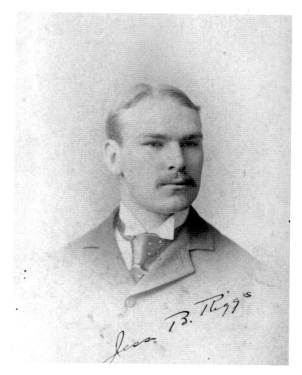

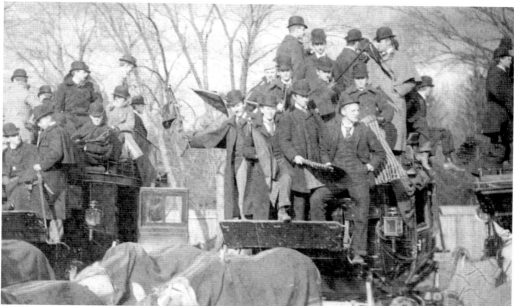

FOOTBALL ON THANKSGIVING. More than 25,000 fans turned out to watch the 1889 Yale game, played on Thanksgiving Day at Berkeley Oval. After a scoreless first half, Princeton pulled away for a 10-0 victory when Hector Cowan returned a fumble for a touchdown. As can be seen, the modern tradition of tailgating was already well under way.

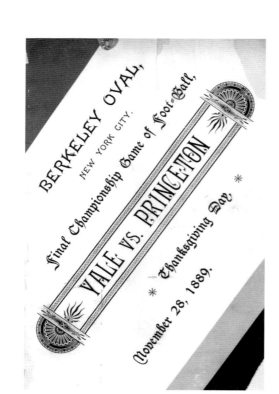

Program from 1889 Yale Game. By the late 1880s, public interest in Princeton football had become so intense that promoters began printing programs, such as this one for the 1889 Yale game. Located at 155th Street and the Harlem River, Berkeley Oval was promoted as "finely turfed and rolled," but a rainstorm turned it into a morass. The Tigers won the game, 10-0, and the title.

Students Lined Up to Buy Tickets. A group of students waits for the chance to buy tickets to the 1891 championship game, which would be played on Thanksgiving afternoon at New York's Manhattan Field. More than 40,000 fans turned out to see what the *New York Times* called "the greatest athletic contest that has ever been witnessed in this city"—unfortunately, a 19-0 Yale victory.

THE EARLY YEARS: 1869–1899

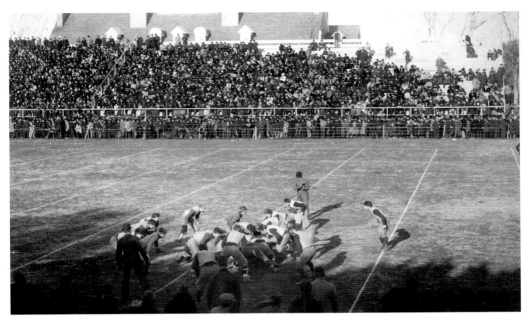

A Rivalry Born in Philadelphia. Princeton played Penn on the grounds of the Germantown Cricket Club in Philadelphia in 1892, shown here. The Quakers, unfortunately, recorded their first-ever victory over the Tigers that day, 6-4. Note the referees in bowler hats and the fences set up along the sidelines to keep the capacity crowd of 18,000 off the field.

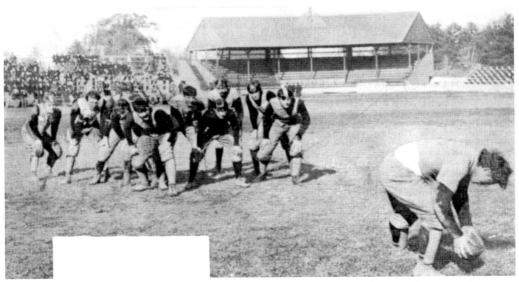

The Flying V Wedge. This was Princeton's answer to Harvard's infamous Flying Wedge. Nine players formed a shield, with the ball carrier tucked in behind them. As a human arrowhead, they mowed down the opposition, but such plays were eventually outlawed because of the damage they inflicted on both teams. The modern rule requiring seven men on the line of scrimmage was introduced to stop such plays.

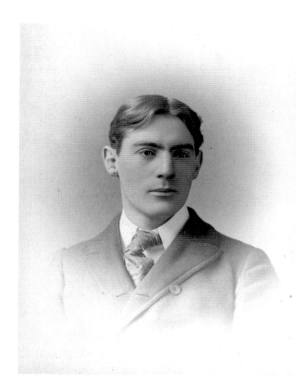

PARKE DAVIS '93. Parke Davis was a longtime member of the football rules committee and later coached at the University of Wisconsin, Amherst College, and Lafayette College, but he won greater fame as a historian. His book, *Football: The American Intercollegiate Game*, published in 1911, was one of the first and most complete histories of the game's early years. In 1933, he retroactively anointed a college football champion for each year from 1869 through 1932.

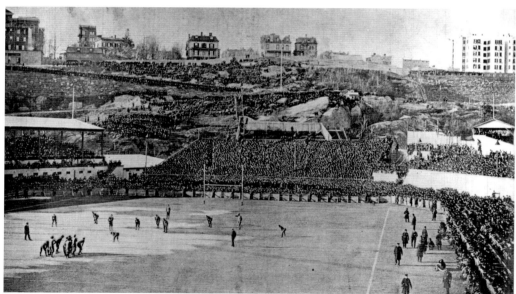

MANHATTAN FIELD, 1893. In order to capitalize on fan interest, many early Princeton games were played in New York, often at Manhattan Field. An overflow crowd, with thousands more perched along Coogan's Bluff, saw the Tigers beat Yale on Thanksgiving Day, 6-0, snapping a 37-game Eli winning streak. Telegraph operators inside the stadium "broadcast" the game live to fans across the country.

PHIL KING '93. Phil King, an All-American quarterback and halfback, was famous for his curly blonde hair, which he wore long to protect his head in the era before leather helmets. He scored 11 touchdowns in a single game against Columbia in 1890 and the only points in the Tigers' 6-0 victory over Yale in 1893. One of the first prominent Jewish American athletes, King would later coach the University of Wisconsin.

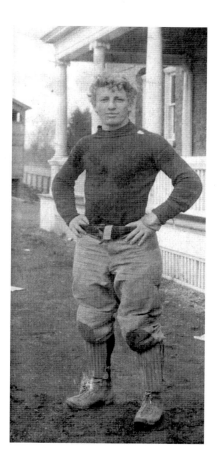

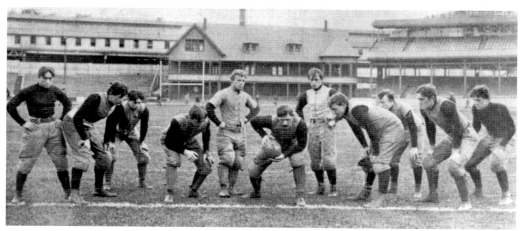

PHIL KING AND THE 1893 TEAM. This photograph, possibly taken at New York's Manhattan Field prior to the Yale game, shows King preparing to take the snap from center David Balliet '94. The Tigers won all 11 games they played that year and outscored their opponents, 270-14.

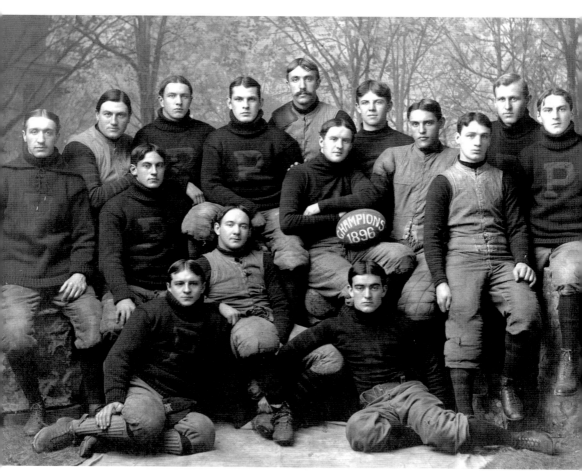

THE 1896 TEAM. A scoreless tie against Lafayette was the only blemish on a 10-0-1 record, with victories over the U.S. Military Academy, Carlisle Indian Industrial School, the University of Virginia, and Pennsylvania State University, as well as drubbings of Harvard and Yale. The team was led by end and captain Garrett Cochran '98, flanker Howard Brokaw '97, center Robert Gailey '97, and back Addison Kelly '98. One historian has pronounced them "the most powerful line yet to don the Tiger stripes." Johnny Poe '95 was not quite a star, but when the team was losing to Harvard, he inspired a comeback by scolding them, "If you won't be beat, you can't be beat." That became Princeton's slogan for a generation afterwards.

THE EARLY YEARS: 1869–1899

LANGDON LEA '96. A tackle, end, and three-time All-American, Langdon Lea, known as "Biffy," was one of the best defensive players of his era. In four seasons, Lea's teams recorded shutouts in 35 of 47 games. He later served as Princeton's first official head coach in 1901 and was elected to the College Football Hall of Fame.

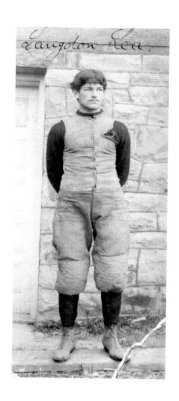

ARTHUR WHEELER '96. A 200-pound guard, Arthur Wheeler, known as "Beef," was named to the All-America teams three times in his career. His defenses recorded 26 shutouts in the 35 games in which he played. Wheeler was inducted into the College Football Hall of Fame in 1969.

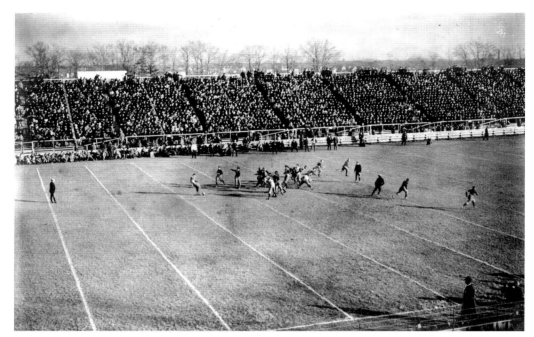

THE 1898 YALE GAME SEEN FROM TWO ANGLES. The Tigers defeated Yale, 6-0, on Brokaw Field in 1898. Arthur Poe '00 returned a fumble 95 yards for the only score of the game, making up for a 90-yard touchdown run earlier that was nullified by a penalty. Temporary bleachers were erected to handle the crowd, estimated to be about 16,500, which included former president Grover Cleveland. Note the photographers along the sideline in the lower photograph. In New York, large crowds followed every play of the action as described by telegraph. After the 2:00 p.m. kickoff, the *New York Times* reported, "it was impossible to get within ten yards" of a telegraph ticker. As for the campus, the paper said, "Princeton was never such a happy town before."

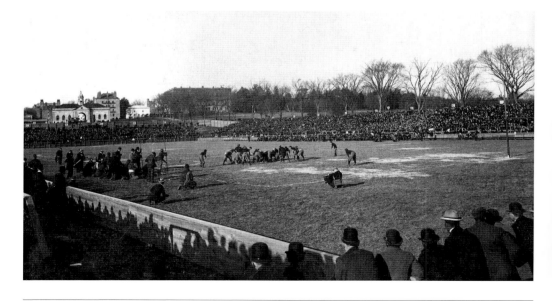

ADDISON KELLY '98 AND WILLIAM BANNARD '98.
Addison Kelly dreamed of playing for Yale but the
Elis shied away because he had been born with
a foot deformity. "You'll be sorry," Kelly said as
he left New Haven, and Yale certainly was. He
became a powerful running back and a two-time
All-American. William Bannard, a punter and
fullback, scored a touchdown in a 12-0 win over
Harvard in 1896.

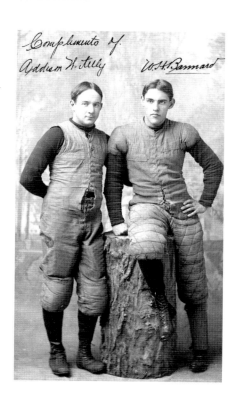

BROKAW FIELD. Princeton played many home games on Brokaw Field during the late 19th
century. The field was named for Fred Brokaw '91, a star athlete who lost his own life while
trying to save a family servant from drowning. The field was used for many activities, including
bayonet training during World War I. It is now the site of Whitman College.

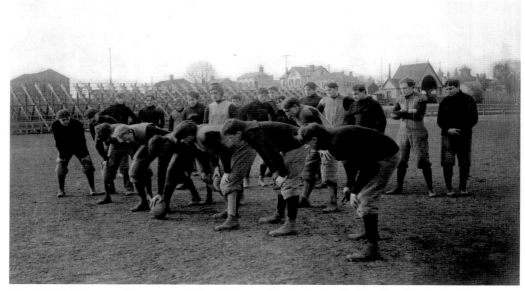

THE 1899 TEAM AT PRACTICE. The 1899 squad, which finished with a 12-1 record, practices putting the ball in play on Brokaw Field as reserves look on. Note the quilted football pants, which contained protective padding, as well as a player in the backfield sporting one of the early leather helmets, testaments to how rough the game had become.

WILLIAM EDWARDS '00. At six feet tall and 225 pounds, William "Big Bill" Edwards certainly was well named. He captained the 1899 champions and was later inducted into the College Football Hall of Fame. In 1910, he was shot in the arm during an assassination attempt against the New York City mayor but wrestled the assailant to the ground. Edwards later served as president of the American Professional Football League.

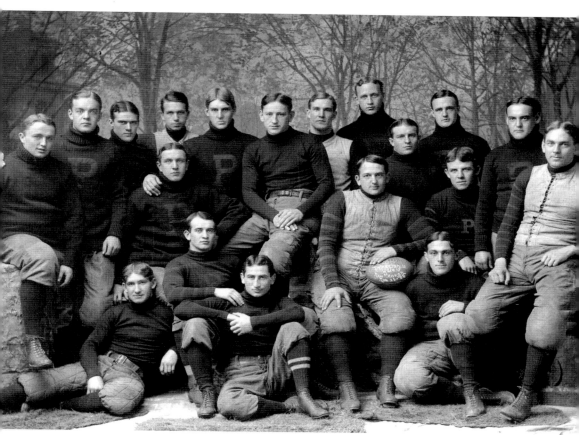

THE 1899 TEAM. These Tigers won the first seven games of the 1899 season by shutout. However, they were ambushed in a surprising 5-0 upset loss at Ithaca to Cornell, the first time they had ever lost to the Big Red. That led coach Biffy Lea '96 and captain Bill Edwards '00 to shake up the lineup and the Tigers responded by outscoring their opponents 60-6 over the next three weeks. As it usually did, the season came down to a showdown against Yale on a frozen field in New Haven. Injuries drove all but three starters out of the game but Princeton got a break when future coach Bill Roper '02 fell on a fumble. Arthur Poe's last-second field goal pulled out a dramatic 11-10 victory.

ARTHUR POE '00. Although he stood five-feet-seven-inches tall and weighed only 146 pounds, Arthur Poe was twice named an All-American at end and seemed to save his greatest exploits for beating Yale. In 1898, he returned a fumble for a touchdown and in 1899, won the game with a 37-yard field goal that he had to kick soccer-style because he had forgotten to bring square-toed kicking shoes.

ARTHUR HILLEBRAND '00. Arthur "Doc" Hillebrand was twice named an All-American tackle. He was also captain of the baseball team and president of his class. In 1903, he coached Princeton to a national championship. In 1905, he and Prof. John B. Fine '82 were summoned to Washington by Pres. Theodore Roosevelt to work out a solution to the problem of brutality in college football.

2

THIS SIDE OF PARADISE

1900 – 1920

Hooray! Hooray! Hooray!
Tiger! Sis! Boom! Ah!
PRINCETON!

POPULAR HEROES. By the end of the 19th century, Princeton football had captured the popular imagination, as this postcard illustrates. The Tigers appeared in other media, as well. Richard Harding Davis's 1886 short story, "Richard Carr's Baby," centered on a heroic Tiger captain who rescues a poor boy. In 1903, Thomas Edison took his new movie camera to New Haven, where he filmed part of Princeton's 11-6 victory over Yale.

JOHN DEWITT '04. A kicker and All-American guard, John DeWitt single-handedly beat Yale in 1903, blocking a punt that he returned 83 yards for a touchdown, kicking the extra point, and then booting a 53-yard field goal in an 11-6 victory. Earlier in the season, he broke off an 80-yard touchdown run in a victory over Dartmouth, and the following week kicked a 50-yard field goal to beat Cornell. (PUAD.)

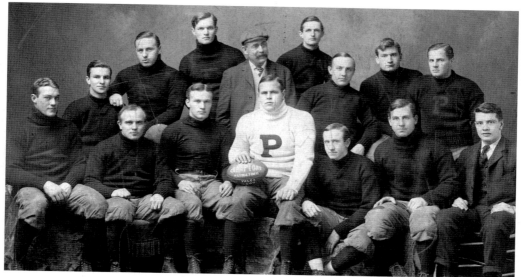

THE 1903 TEAM. The 1903 season was voted Princeton's greatest of the century. The team went 11-0, outscored their opponents 259-6, and surrendered those six points only in their last game. When the team gathered for this group photograph, captain John DeWitt '04 wore his tattered jersey. The photographer offered him a white sweater instead. To this day, captains of championship teams are entitled to wear a white letter sweater.

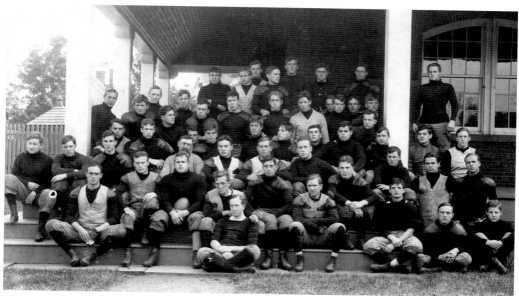

THE CHAMPIONS TAKE A BREAK. Shown on the steps of the field house, the 1903 champions relax after a hard practice. Team captain John DeWitt '04 holds the practice ball. The man in the mustache seated behind DeWitt is trainer James Robinson. If the coach had control over the men on the field, Robinson was in charge of them off it, directing their training regimen and diet. He also worked with the track team.

PRINCETON FOOTBALL

JOHN B. FINE '82. John B. Fine was Princeton's athletic director and its representative on the football rules committee. In October 1905, Pres. Theodore Roosevelt summoned Fine and coach Art Hillebrand, along with representatives of Harvard and Yale, to the White House for a summit on ways to make football less brutal. The conference led to changes that saved the game, including the institution of the neutral zone and the forward pass. Fine also founded and was the longtime headmaster of the Princeton Preparatory School.

THIS SIDE OF PARADISE: 1900–1920

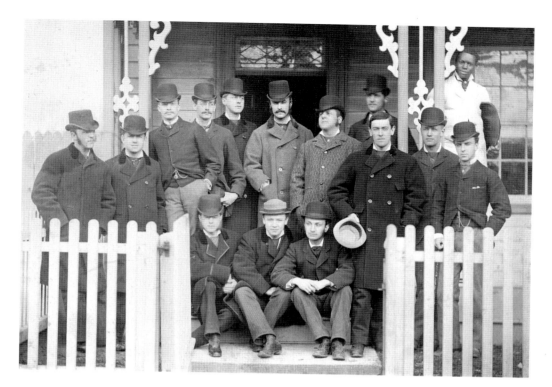

WOODROW WILSON '79. As an undergraduate, the future president of Princeton (1902–1910) and the United States (1913–1921) served as the Tigers' manager. Woodrow Wilson is seen in the top photograph (standing, third from right) as a member of the Princeton Alligators, an early eating club. Wilson remained a football fan for the rest of his life. Following Princeton's 6-4 loss to Penn in 1892, Wilson's wife told a friend that only Grover Cleveland's victory in the presidential election had revived his spirits. "I think Woodrow would have had some sort of collapse if we had lost in politics, too!" she wrote. While Princeton's president, Wilson helped arrange the first meeting with his counterparts at Harvard and Yale to retake control of college football. That grouping would eventually lead to the creation of the Ivy League.

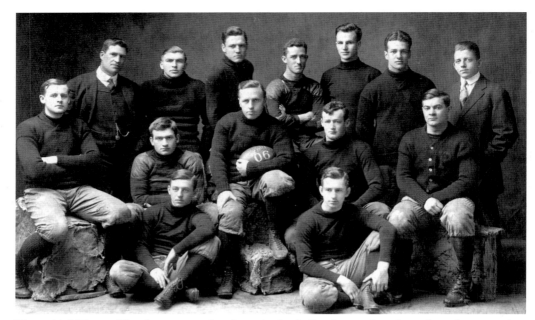

THE 1906 TEAM. The first year under the new football rules produced another championship season for the Tigers, their only blemish being a scoreless tie against Yale. It was also Bill Roper's first season as coach.

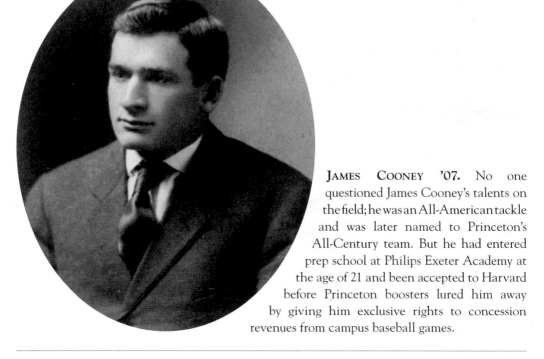

JAMES COONEY '07. No one questioned James Cooney's talents on the field; he was an All-American tackle and was later named to Princeton's All-Century team. But he had entered prep school at Philips Exeter Academy at the age of 21 and been accepted to Harvard before Princeton boosters lured him away by giving him exclusive rights to concession revenues from campus baseball games.

Caspar Wister '08. In a game against Villanova University in 1906, Caspar (Cap) Wister was on the receiving end of a forward pass from quarterback Eddie Dillon '09 who, like Wister, was also an All-American. It was the first successful forward pass in Princeton history. However, Wister earned his place on Princeton's All-Century team as a defensive lineman.

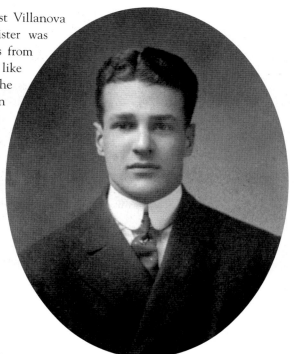

James McCormick '08. James McCormick was an All-American fullback in 1905 and 1907, and a second teamer in 1906. He scored two second-half touchdowns to beat Columbia University in 1905. He was chosen to coach the Tigers in 1909 and elected both to the College Football Hall of Fame and to Princeton's All-Century team as a linebacker.

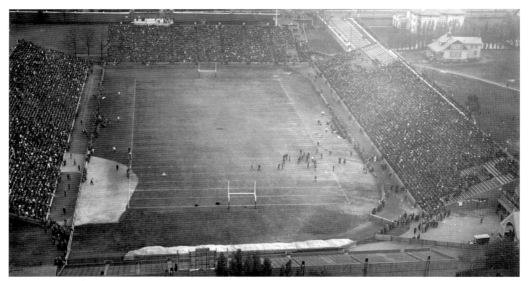

THE FIRST FOOTBALL GAME PHOTOGRAPHED FROM AN AIRPLANE. When Princeton upset a heavily favored Harvard team, 8-6, in 1911 at University Field, James Hare of *Collier's* magazine recorded the action from a Wright biplane. The *New York Times* wrote that Princeton "awed the Crimson team with the stunning surprise of their power." It was the first time the two schools had played each other in 15 years.

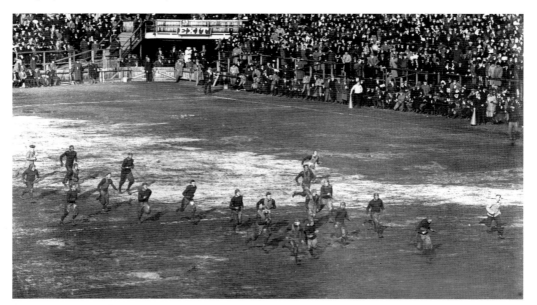

SANFORD WHITE'S TOUCHDOWN RUN AGAINST HARVARD, 1911. On the ground, the action was no less exciting. In the second quarter, Princeton blocked a Crimson field goal attempt, which Sanford White scooped up and returned 90 yards for a touchdown. He later added a safety in the 8-6 victory. F. Scott Fitzgerald, then in prep school, wrote next to his ticket stub in a scrapbook, "Sam White decides me for Princeton."

THIS SIDE OF PARADISE: 1900–1920

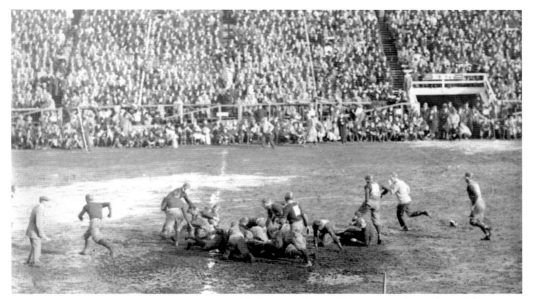

PRINCETON UPENDS YALE, 1911. Two weeks later, White did it again. The Yale Bulldogs were a slight favorite when the two teams met in New Haven. Although the field was sloppy, White broke off a 65-yard touchdown run, earning himself the nickname "Long Run Sammy." The Tigers surprised the Elis with a 6-3 victory, their first in the rivalry since 1903.

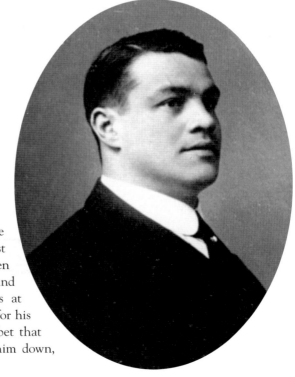

EDWARD HART '12. Grantland Rice called Eddie Hart "one of the greatest tackles of all time." He suffered a broken neck playing football in high school and wore a brace for his first three years at Princeton but was nevertheless known for his prodigious strength. Hart once won a bet that three Army players could not knock him down, even if he stood on one foot.

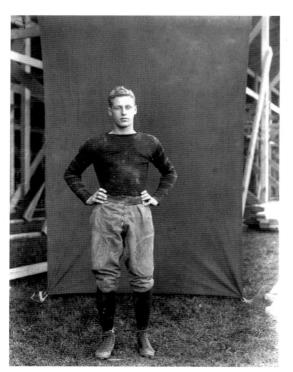

HOBART AMORY HARE BAKER '14.

F. Scott Fitzgerald called Hobart Amory Hare (Hobey) Baker "an ideal worthy of everything in my enthusiastic imagination" and named the protagonist of his novel *This Side of Paradise* Amory in his honor. Baker led Princeton to two national championships and scored 92 points in 1912 as a runner, kicker, and punt returner, a school record that stood for more than half a century. He learned drop kicking from Snake Ames '92 and those kicks accounted for every one of Princeton's points in the 1912 and 1913 Yale games. Baker was also one of the best hockey players in the country, the only man inducted into both the College Football and Hockey Halls of Fame. He became a fighter pilot during World War I, but died in a crash days before he was to return home.

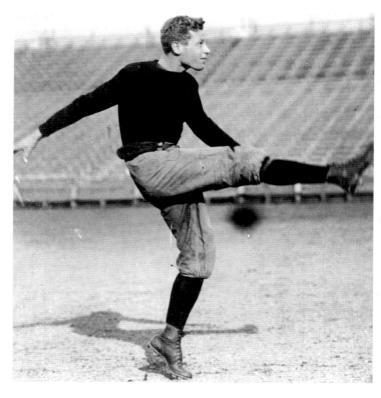

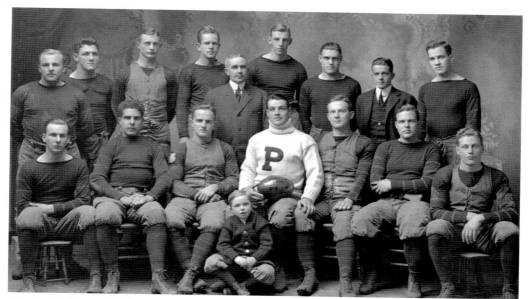

THE 1911 TEAM. Hobey Baker (far right) returned 13 punts against Yale, which remains a Princeton single-game record. The team, led by captain Eddie Hart '12 (in white sweater), went 8-0-2 for another national championship. Other stars included quarterback Tal Pendleton '13 and Wallace DeWitt '12. Tom Wilson '13 later led the Princeton Football Association.

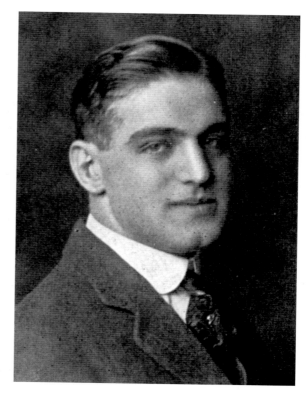

HAROLD BALLIN '15. Too small to play football at the Lawrenceville School, Harold Ballin bulked up and learned the tackle position from Eddie Hart '12, stepping in when Hart graduated. He won consensus All-America honors as a junior and senior. He played every minute of every game during the 1914 season and is also the last Princeton player to play without a helmet. Ballin was selected to Princeton's All-Century team.

F. Scott Fitzgerald '17. On the day he passed the Princeton entrance examination, F. Scott Fitzgerald wired his mother, "Admitted, send football shoes and pads immediately." He was not much of a player, unfortunately, and was cut from the freshman squad after the first day of practice, but he remained a fan for life and captured the university and an era in a way that no one else ever has. "At Princeton, as at Yale" he wrote once in an essay, "football became, back in the nineties, a sort of symbol . . . at first satisfactory, then essential and beautiful. It became, long before the insatiable millions took it . . . the most intense and dramatic spectacle since the Olympic games."

THIS SIDE OF PARADISE: 1900–1920

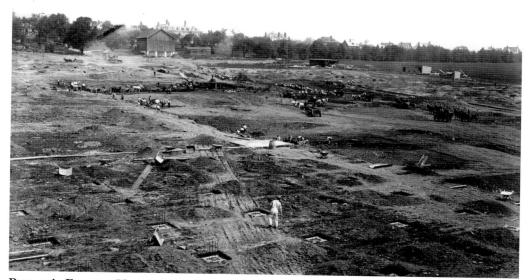

PALMER'S FUTURE HOME. This photograph shows early work on the construction of Palmer Stadium, which would open in time for the 1914 season. Construction was completed in just four months as workmen were divided into two crews, one in charge of the east side of the stadium and one in charge of the west side. The two competed throughout the summer to see which could finish their side first.

THE FIRST GAME IN PALMER STADIUM. Although Palmer Stadium was officially dedicated at the 1914 Yale game, the Tigers first played there three weeks earlier, defeating Dartmouth, 16-12, before a less-than-capacity crowd of 10,000. Knowlton Ames Jr., whose father had starred in the 1880s, is seen here scoring the first touchdown. This was also possibly the first game in which the Tigers wore numbers on their uniforms.

PRINCETON FOOTBALL

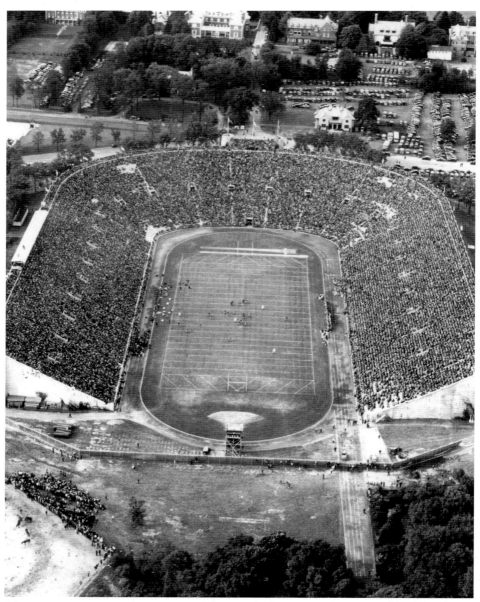

PALMER MEMORIAL STADIUM. The second-oldest football stadium in the country, after Harvard Stadium, Palmer Stadium seated more than 42,000 fans and was usually packed. For big games, temporary seats could be erected in the open end of the horseshoe, expanding its capacity to 53,000. It was given by Edger Palmer '03 in honor of his father, Stephen S. Palmer, a former university trustee. Until 1941, home fans sat on the east side of the stadium, which forced them to squint into the setting sun. During its more than 80-year history, Palmer Stadium also hosted numerous other events, including track meets, lacrosse games, and NFL exhibition games. Although the stands were torn down after the 1996 season, a new stadium was built on the site and Princeton still plays on the same field. (PUAD.)

TALBOT PENDLETON '13. Talbot (Tal) Pendleton began his career as a quarterback but was switched to halfback before his senior season when Princeton introduced an unbalanced line in which the backs lined up behind the tackles. This enabled Pendleton, the team captain, and Hobey Baker to break outside for big gains. In 1911, Pendleton returned a kickoff 100 yards for a touchdown against Rutgers.

KEENE FITZPATRICK. Keene Fitzpatrick, Princeton's athletic trainer for more than 20 years, is considered one of the great figures in American intercollegiate sports. He coached several Olympic gold medalists and is credited with inventing the modern pole-vaulting technique. Bill Edwards recalled a day when he could not find his uniform and asked Fitzpatrick if he had seen it. "It's outside," the trainer replied. "We made a dummy out of it."

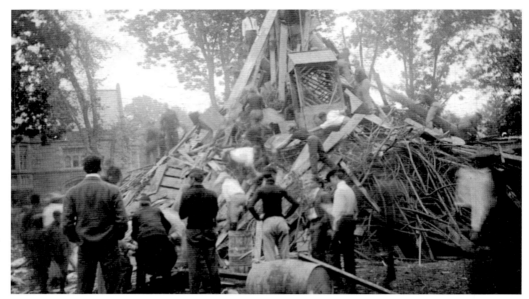

BUILDING A BONFIRE. The Princeton bonfire is believed to have originated as a baseball tradition rather than a football tradition, but over time it became a way to celebrate winning the unofficial "Big Three" title over Yale and Harvard. Freshmen, like those seen in this undated photograph, piled old furniture and anything else they could find and set it ablaze on Cannon Green.

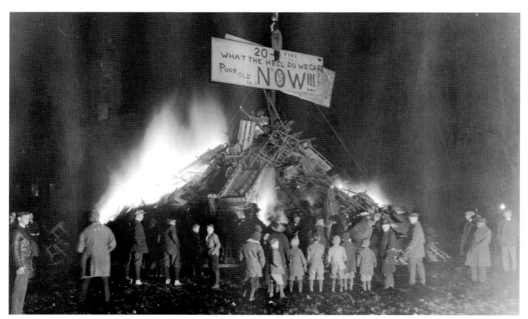

A VICTORY BONFIRE. The Tigers forged a 14-14 tie against Harvard during the 1920 season, then bounced back the following week to crush Yale, 20-0, and give the campus an excuse to celebrate and kick off the Roaring Twenties. A sign placed atop the blazing pyre quotes a line from the popular song, "Hail, Hail the Gang's All Here."

BETWEEN THE WARS

1921–1940

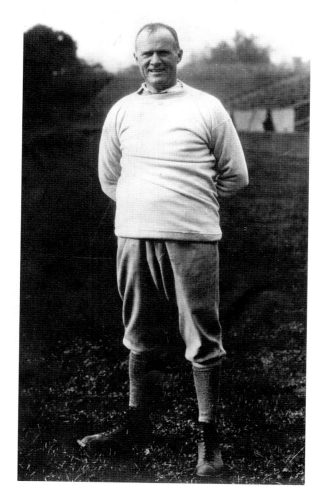

WILLIAM ROPER '02. William Roper played on the Tigers' 1899 championship team, then returned to coach them three times, mixing in coaching turns at Virginia Military Institute (VMI), University of Missouri, and Swarthmore College. He was more of a motivator than an innovator, but he motivated Princeton to four undefeated seasons and five more with only one loss. And he did all this while simultaneously serving as a Philadelphia city councilman.

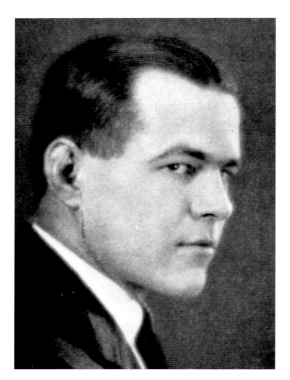

FRANK MURREY '22. "And Yale with three points to the good—ah shame that this should be— / To see the scoreboard give Yale 6 and Princeton only 3! / But lo! Frank Murrey kicks a goal, and now the score is tied; / At least Yale does not win the day, whatever else betide." So ran a poem by two students commemorating the Tiger's 13-6 victory in 1919. Murray was named to the All-Century team.

STAN KECK '21. Stan Keck was a 230-pound All-American guard and tackle in 1920 and 1921, leading the team to a national championship as a junior. After playing the 1923 season as a place kicker with the Cleveland Indians of the fledgling National Football League, where he was named a second team All-Pro, Keck served as an assistant coach for the Tigers.

DONALD LOURIE '22. A future hall or famer who could run, pass, and kick, Donald Lourie won All-America honors at quarterback in 1920 and also played safety. Both the annual football banquet and the award honoring the best offensive freshman player are named in his honor. An internationally celebrated long-jumper, as well, Lourie led a Princeton-Cornell team to victory over a squad from Oxford and Cambridge in 1922, leaping 22 feet 4 inches.

HARLAND BAKER '22. Harland "Pink" Baker was a tackle on the 1922 Team of Destiny and stayed close to the Princeton program for the rest of his life. For 60 years after graduation he coached and mentored the freshman team, becoming known as the freshman football player's best friend. The award honoring the best defensive freshman player is named in his honor.

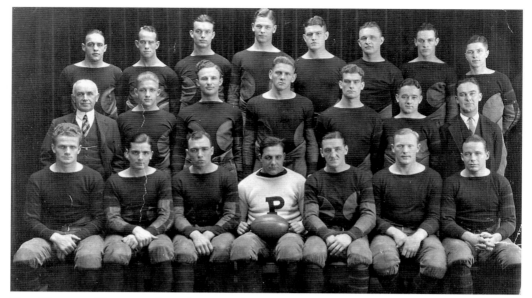

THE TEAM OF DESTINY. A perfect record, a victory over the University of Chicago, and a national championship would have ensured immortality for the 1922 squad, but there was something unique about them. Coach Bill Roper reminded them of a motto Johnny Poe '95 had given Roper as an undergraduate: "If you won't be beat, you can't be beat." Sportswriter Grantland Rice gave them a nickname: Team of Destiny. (PUAD.)

A TEAM OF DESTINY REUNION. "There were no stars [on the 1922 Princeton team]," wrote the *New York Times* after they closed the season with a gritty 3-0 victory over Yale, "just a football squad fired with the desire to do something to add to the glory of Old Nassau." The champions are shown here celebrating their 40th reunion in 1962. (PUAD.)

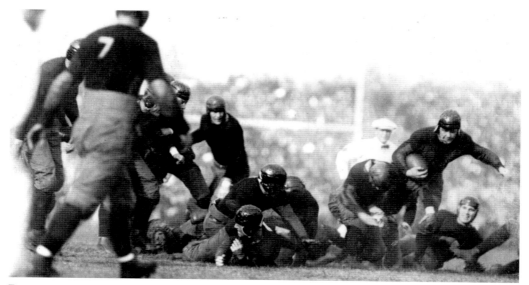

PRINCETON DEFEATS THE UNIVERSITY OF CHICAGO, 1922. No eastern team had ever played in the West before the Tigers journeyed to take on Amos Alonzo Stagg's Maroons. More than 100,000 ticket requests were received to fill the 32,000-seat Chicago stadium. Princeton rallied from an 18-7 fourth-quarter deficit to win, 21-18, clinched with a dramatic goal line stand. The game was the first ever broadcast nationally on the radio.

HOWARD GRAY '23. One of the heroes of the victory over the University of Chicago was Howard "Howdy" Gray, who returned a fumble 42 yards for a touchdown that ignited the Tiger comeback. His excited father whacked a woman in the stands with his program. "That's my wife!" her husband complained. "That's my son!" the father answered. Gray later became a noted surgeon at the Mayo Clinic.

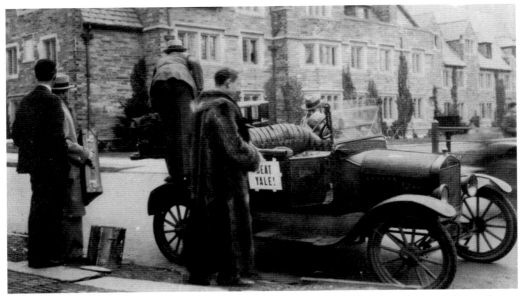

AN EARLY ROAD TRIP. The Roaring Twenties were well underway when these undergraduates packed themselves and a raccoon coat into their Model A Ford for a road trip to New Haven in 1925. The Tigers upset Yale, a 2-1 pregame favorite, by a score of 25-12, capped when Jack Slagle '27 took a reverse on a punt return and ran 82 yards for a touchdown.

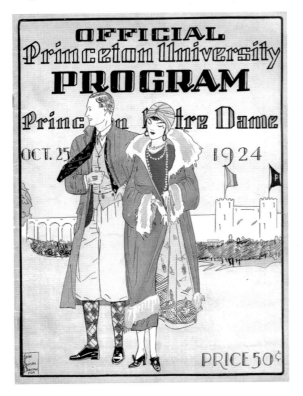

NOTRE DAME VISITS PRINCETON, 1924. Coach Knute Rockne visited Palmer Stadium in 1923 and returned with his Four Horsemen in 1924, winning both times. The 12-0 defeat in 1924 had positive consequences for Princeton, though. Charlie Caldwell '25, a fullback and linebacker on the team, was dazzled by Rockne's sophisticated offense and decided that day that he wanted to become a coach himself.

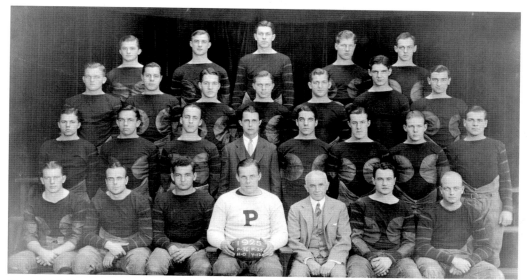

THE 1925 TEAM. The 1925 Tigers rolled over Harvard (36-0) and Yale (25-12) for the unofficial Big Three championship and a bonfire on Cannon Green. Center and captain Edward McMillan '26 holds a game ball, seated next to assistant coach Net Poe. McMillan was an All-American that year while Jack Slagle '27 ("the best all-around player the game has known in years," said Grantland Rice) made second team.

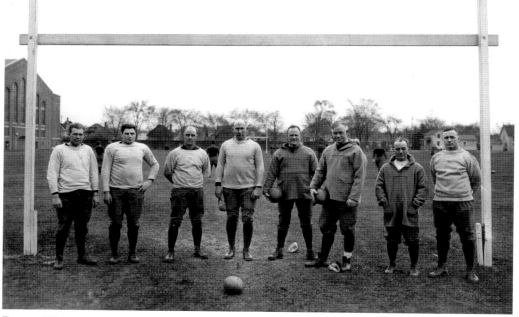

ROPER, WIEMAN, AND POE. The Princeton and Michigan coaching staffs meet in Ann Arbor. Tiger coach Bill Roper (left) and Wolverine coach Fielding Yost hold footballs. Future Tiger coach Ted Wieman, then a Michigan assistant, is fourth from the left. Neilsen Poe is second from the right.

HARVARD–PRINCETON

November 6 1926 OFFICIAL 25 *Cents*

THE 1926 HARVARD GAME. There had been bad blood between the teams for years and Harvard wanted to drop Princeton from its schedule. A brutal 12-0 Princeton victory in 1926 and an insulting issue of the *Harvard Lampoon* led Princeton to move first, severing all athletic ties with the Crimson. The two schools did not meet again on the gridiron until 1934.

JOSEPH PRENDERGAST '27. A magazine article alleged that Princeton players had punched Harvard's Al Miller with their signet rings during the 1926 game. Princeton did not wear signet rings, but Prendergast, a star halfback, wore a family ring. "I don't believe your story," he wrote Miller, "but if it is true then I want you to know that the 'P' on your nose stands for Prendergast and not Princeton."

The Buckeyes Come to Palmer Stadium, 1927. Princeton replaced Harvard on its schedule by arranging a home-and-home series against Ohio State in 1927 and 1928. The Tigers shut out the visiting Buckeyes, 20-0, in 1927 thanks to three touchdowns by halfback Ed Wittmer. The teams tied, 6-6, in a rematch before 74,000 fans at Columbus the following year.

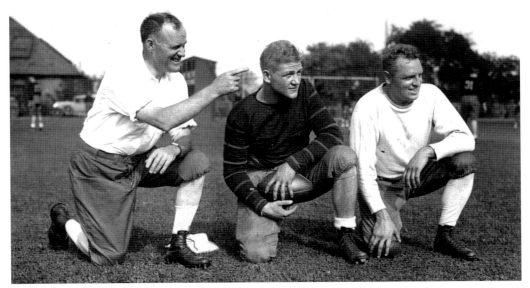

Two Princeton Coaches. Bill Roper (left) gives instructions to captain Ricardo Mestres '31 as assistant coach Al Wittmer '22 looks on. Wittmer succeeded Roper as Princeton's head coach in 1931, after Knute Rockne backed out, but Wittmer had a short and stormy reign, going 1-7 in his only season. Mestres, on the other hand, became a successful lawyer, financial vice president of Princeton, and the first executive director of the Ivy League.

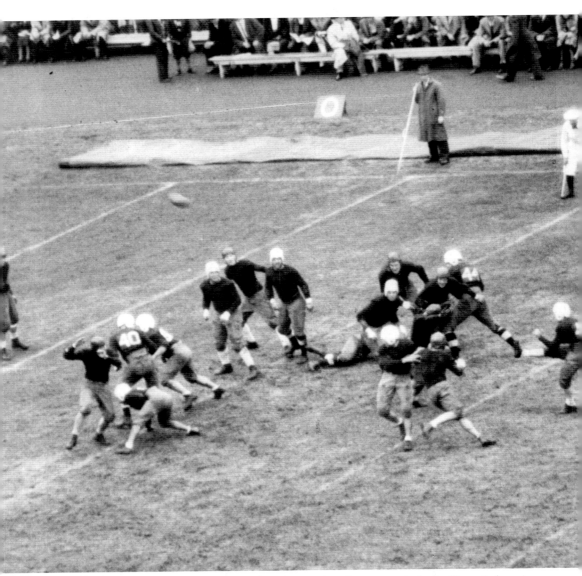

BILL ROPER'S FINAL GAME, 1930. The Tigers played competitively in Roper's last season, although their record did not reflect it. They led Yale at halftime of their final game, thanks to a mud-soaked field that slowed the Bulldogs' slippery back, Albie Booth. Booth managed to kick a field goal, shown here, to put Yale ahead before Princeton started its final drive. But quarterback Holmes "Trix" Bennett '31 was stopped inches short of the goal line on fourth down. "The mud-stained pigskin is four inches short," wrote George Trevor in the *New York Sun* the next day. "That's why the big bronze bells of Nassau Hall are silent as the dazed crowd slowly trickles out of Palmer Stadium. . . . They never rang so loudly as the night they never rang at all." (PUAD.)

BETWEEN THE WARS: 1921–1940

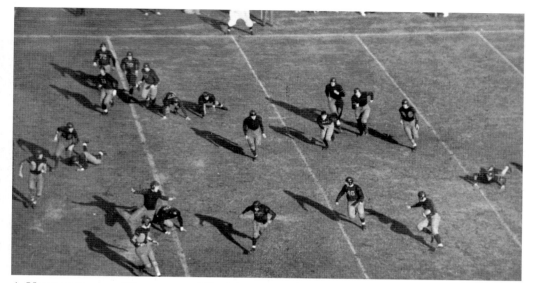

A VISIT FROM THE WOLVERINES. The University of Michigan traveled to Palmer Stadium to play the Tigers in 1931, their only season under coach Al Wittmer. The Wolverines won easily, 21-0, as Princeton failed to make a single first down. That and six other losses after an opening win against Amherst were enough to persuade the football committee that changes needed to be made.

F. TREMAINE BILLINGS JR. '33.
F. Tremaine "Josh" Billings played under four different coaches and was one of the greatest scholar-athletes in Ivy League history. Captain of the football team, president of his class, a Phi Beta Kappa student, and Rhodes scholar, Billings overcame polio to earn his medical degree from Johns Hopkins. He served as a professor at the Vanderbilt medical school for almost 50 years.

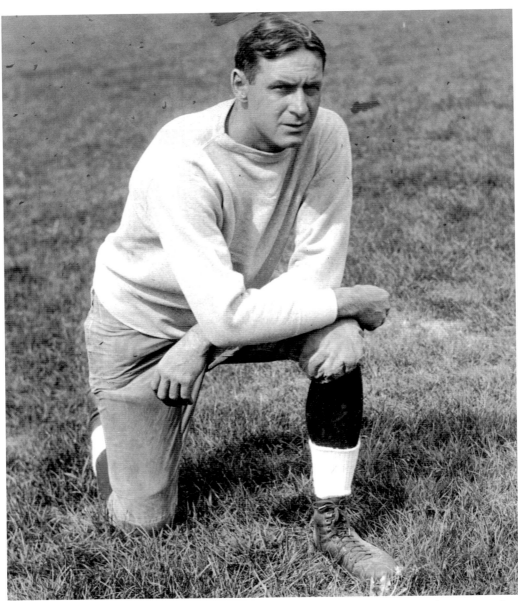

HERBERT O. CRISLER. Princeton hired Fritz Crisler away from the University of Minnesota but he had learned the game as a player for Amos Alonzo Stagg at the University of Chicago and built the Tiger offense around the single wing, which would be its distinctive feature for the next 35 years. Crisler was the first Princeton coach who was not an alumnus. He arrived in town on the night the Lindbergh baby was kidnapped in Hopewell, just up the road. Driving around the next morning in a borrowed car, Crisler was brought in for questioning until Hack McGraw '20, a prominent alumnus and a partner at McGraw-Hill, vouched for him. Crisler was 35-9-5 in six seasons, including perfect records in 1933 and 1935. He also introduced the winged helmet design, which is meant to suggest a charging tiger.

HARD WORK PAYS OFF. Fritz Crisler brought a renewed dedication to Princeton's football program. His single-wing offense demanded perfect timing and peak physical conditioning. In these two photographs, the team practices blocking and tackling, in both cases under the supervision of assistant coach Stan Keck '21, who had been an All-American during his own days with the Tigers. The work quickly paid dividends as the Tigers rebounded from a 2-2-3 record in 1932 to a perfect 9-0 the following year.

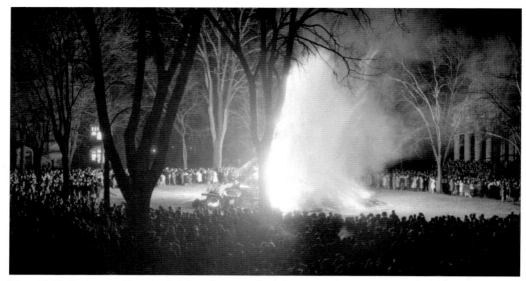

THE 1933 BONFIRE. Hundreds of students gathered on Cannon Green for a great conflagration to celebrate the 1933 national championship. They outscored their opponents 217-8 that season and received inquiries from the Rose Bowl Committee about making the trip to Pasadena. University president Harold Dodds refused, citing Princeton's long-standing policy forbidding post-season play, and so Columbia received the bid instead.

ARTHUR LANE '34. Arthur Lane was the second consecutive Princeton football captain to win the Pyne Honor Prize. As a tackle, he led the Tigers to a perfect record in 1933. Elected president of his class every year, Lane went on to a career as a naval officer, prosecutor, and state judge. The Art Lane Award is given to an undergraduate who has made selfless contributions to sport and society. (PUAD.)

CHARLES CEPPI '34. Charles Ceppi was, in *Time* magazine's words, a "hard-hitting tackle" who also handled kicking duties and won consensus All-America honors as part of the 1933 championship team. In 1933, Ceppi blocked a Yale punt and returned it 35 yards for a touchdown in a 27-2 pasting of the Elis. One sportswriter wrote that Ceppi "knocks down trees along Prospect Street to keep in trim."

ELWOOD KALBAUGH '35. Some called him "Mose" and others "Moose," but the strapping Elwood Kalbaugh was a first-team All-American in 1934 at center. In that season, he intercepted a Yale pass and returned it 24 yards in a losing effort against the Elis. The following summer, Kalbaugh and Michigan's Gerald Ford were the two centers on an all-star collegiate team that played an exhibition game against the Chicago Bears.

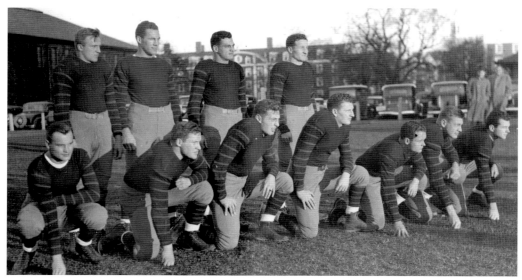

THE FIRST GAME AGAINST HARVARD. After an eight-year hiatus, Princeton and Harvard resumed their gridiron rivalry at Cambridge in 1934. The *Princeton Tiger* and *Harvard Lampoon* published a joint edition to prove that there were no hard feelings and the Harvard band serenaded visiting Princeton fans. The team, including center Elwood Kalbaugh (kneeling, fourth from left) and quarterback John Kadlic (standing, far left), posed for a photograph before the game.

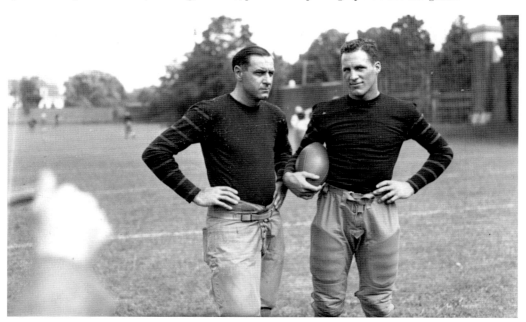

FRITZ CRISLER AND W. PEPPER CONSTABLE '36. W. Pepper Constable (right) captained the undefeated 1935 national champions and, like his predecessor Art Lane, was elected class president all four years. He became a doctor and was the longtime chief of the Princeton Medical Center. The star fullback here receives some instruction from his coach at University Field.

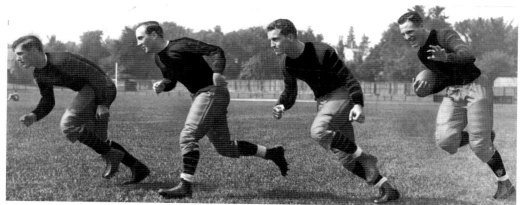

A Tough Backfield to Stop. Four members of the backfield on the 1935 national championship team pose during practice. They are, from left to right, Homer Spofford '36, Garry LeVan '36, Ken Sandbach '37, and Pepper Constable '36.

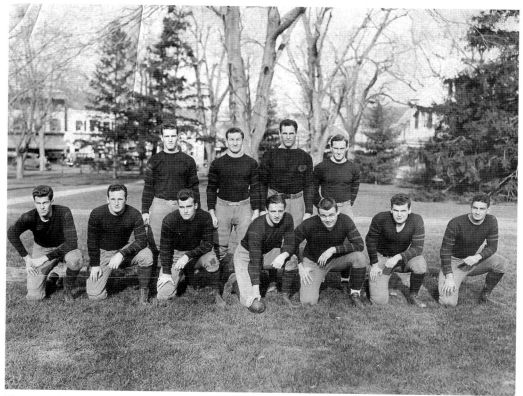

The 1935 Team. The team started shakily, then rolled through the rest of its schedule for a perfect record and a national title. The starting lineup is shown here before the Yale game. From left to right are (first row) Gil Lea, Fred Ritter, Thomas Montgomery, Stephen Cullinan, Jac Weller, George Stoess, and Hugh MacMillan; (second row) Ken Sandbach, Paul Pauk, Pepper Constable, and Garry LeVan.

PRINCETON FOOTBALL

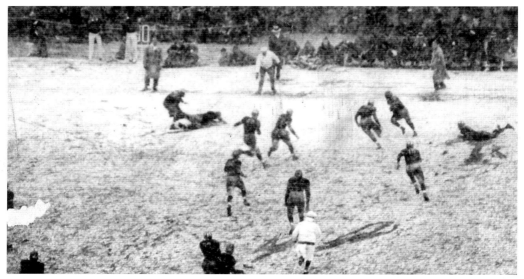

THE 12TH MAN GAME. One of the oddest plays in Tiger history came late in a 1935 snowstorm victory over Dartmouth. With the Tigers threatening to score again, a fan jumped out of the Palmer Stadium stands and threw himself into the Dartmouth line. No one thought to get the intruder's name but two local men quickly stepped forward to claim that they had been Dartmouth's 12th man. (PUAD.)

JAC WELLER '36. John Allan Claude Weller, known to everyone as "Jac," was an All-American guard and future College Football Hall of Famer. Coach Tad Wieman pronounced him the greatest lineman he had ever coached. When a drunken fan rushed onto the field during the 1935 Dartmouth game, it was Weller who helped toss him out. Weller later opened a successful insurance agency and wrote books on military strategy.

FOUR MEMBERS OF THE 1936 TEAM HUDDLE UP. Seen here are, from left to right, Dean Hill '37, Ken Sandbach '37, Charles Kaufman '37, and Jack White '37. White scored two touchdowns in a loss to Yale. Sandbach, the team's kicker, booted a field goal to provide the only points in a 3-0 victory for the East in a 1937 East-West Shrine game.

GARRET LEVAN '36. A fleet halfback, Garry LeVan was one of the stars of the Tigers' 1935 championship team. *Time* magazine wrote, "LeVan's rocket-like rushes and nimble defense work made him the first publicized star of the Crisler football renaissance at Princeton." A 1943 magazine article named Garry LeVan the most elusive punt and kickoff returner of the previous decade.

PRINCETON FOOTBALL

TAD WIEMAN. When Fritz Crisler left Princeton to coach at Michigan after the 1938 season, his longtime assistant, Elton "Tad" Wieman, was named to replace him. A Michigan alumnus himself, Wieman interrupted his college studies to enlist in World War I but returned to graduate Phi Beta Kappa. He coached Princeton for five seasons and is shown here in 1938 with captain Thomas Mountain.

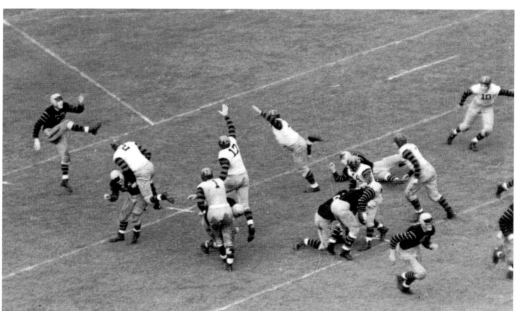

THOMAS MOUNTAIN '39. The 1938 season was George Munger's first as head coach at Penn, but Princeton easily defeated the Quakers 13-0, thanks to plays like this punt by captain Tom Mountain, who also served as the team's halfback. Four weeks later, he keyed a 20-7 victory over Yale. In 2008, Mountain became the oldest living Princeton football captain. (PUAD.)

Van Lengen in Action. Three Penn Quakers converge on Robert "Bronc" Van Lengen '40 in a 13-0 Tiger victory at Palmer Stadium in 1938. Off the field, Van Lengen was a philosophy major and classical Greek student who enjoyed opera. He served as an intelligence officer in England during World War II and became a lawyer, while also working as a college football referee on Saturdays. (PUAD.)

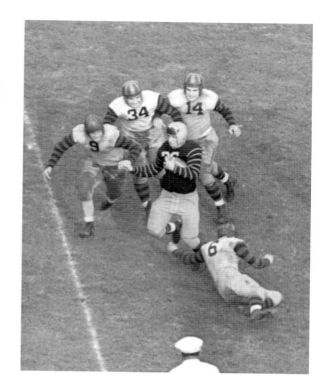

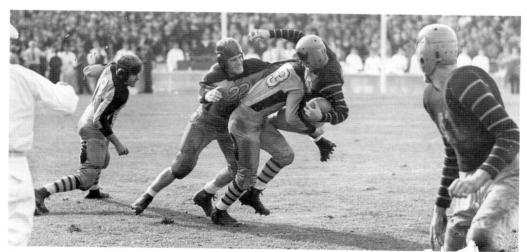

Van Lengen Brought Down Hard. Here Bob Van Lengen is brought down roughly after catching a pass in a 14-7 Princeton victory at Columbia in 1939. Quarterback Dave Allerdice '41 attempted only seven passes in the game but completed four of them for 111 yards. The 1939 squad was coach Tad Wieman's best, finishing 7-1. (PUAD.)

TAILGATING THE OLD FASHIONED WAY. Members of the class of 1930 give their tailgate an old fashioned touch as they embark up Broadway for the Tigers' game against Columbia at Baker Field in 1939. If they were late, they missed most of the action as Princeton struck twice in the first five minutes of the game, gaining all the points they would need in a 14-7 victory over the Lions.

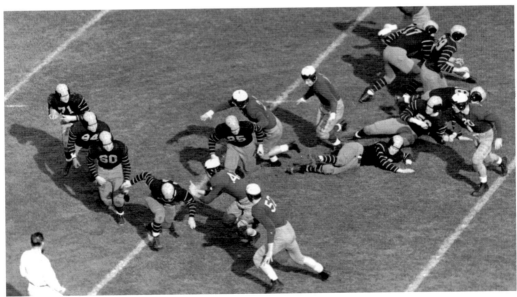

THE SINGLE WING IN MOTION. The single-wing offense, long the hallmark of Princeton football, unfolds beautifully in this play from a 10-7 victory over Yale in 1940. Halfback Bob Peters (71) sweeps right, following blocks by quarterback Dave Allerdice (84), Paul Busse (60), Robert Jackson (44), and Charles Robinson (25). Allerdice later hit Peters on a 51-yard scoring pass and Busse helped seal the victory with an interception. (PUAD.)

BETWEEN THE WARS: 1921–1940

THACHER LONGSTRETH '41. Thacher Longstreth (41) dives on a loose ball in Princeton's victory over Brown in 1939. The 6-foot-6-inch end was an honorable mention All-American despite eyesight so poor that when he was sent into games, he had to give his glasses to the trainer and make his way onto the field by following the referee's white shirt. He was one of the first players to wear contact lenses.

PRINCETON'S GREATEST FAN. An advertising executive, two-time mayoral candidate, and longtime Philadelphia city councilman, Thacher Longstreth was also perhaps one of Princeton's greatest fans. From 1949 until shortly before his death in 2003, he attended every Tiger football game, home and away, a streak of more than 450 consecutive games. (Photograph by Beverly Schaefer.)

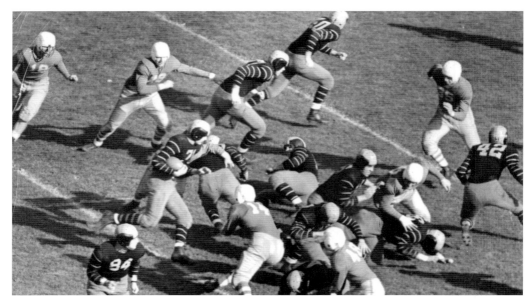

ROBERT PETERS '42. Bob Peters was one of Princeton's great backs, and its last big star before World War II. A triple threat who could run, pass, and kick, he was perfectly suited to the single-wing offense. He is shown here picking up yardage in the Tigers' 28-13 victory over Rutgers in 1940, handing the Scarlet Knights their first loss of the season.

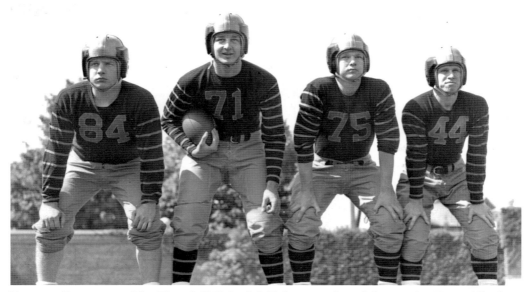

PREWAR BACKFIELD. The Tigers' 1940 backfield features, from left to right, Dave Allerdice, Bob Peters, Paul Busse, and Robert Jackson. Allerdice's father had been the head coach at the University of Texas and his son went on to become a career U.S. Air Force officer. He averaged 16 yards per completion during the 1940 season, still a team record. Busse intercepted three passes against Yale that season, which also remains a record.

BETWEEN THE WARS: 1921–1940

CALDWELL AND HEISMAN

1941–1957

THE WAR YEARS. Princeton, Harvard, and Yale played their traditional schedules in 1942, but wartime travel restrictions and the loss of young men to military service forced them to curtail their football programs afterwards. The Tigers fielded only informal teams in 1943 and 1944 but returned to action with the war's end. They shut out Navy 10-0 at Yankee Stadium in 1942, in Tad Wieman's last season as coach.

NAVY
PRINCETON

OCTOBER 10 • 1942 FIFTY CENTS
YANKEE STADIUM NEW YORK

With Dave Allerdice leaving us along with a number of other valuable seniors, most Princetonians have taken a pessimistic attitude towards next year. This I do not share. We have some excellent veteran material to start off with, material that has been to the wars and should be able to hold its own in any company. Look them over.

At ends we have returning Bruce Wilson and Schmon, with Wilson slated to carry on with the good work he was doing at the end of this year

FITZGERALD'S FATAL HEART ATTACK.

F. Scott Fitzgerald remained a Princeton football fan long after graduation, peppering the coaches with advice, whether they wanted it or not. On December 21, 1940, he was scribbling notes in the margins of an article in the alumni magazine outlining the Tigers' prospects for the coming season when he suffered a fatal heart attack.

GEORGE P. SHULTZ '42. George P. Shultz showed promised in the Tiger backfield as a junior, but a knee injury ruined his senior season. He helped out as a coach instead, developing a love of teaching that led him to become a professor at MIT, the University of Chicago, and Stanford University. Shultz also served as labor and treasury secretary under Richard Nixon and secretary of state under Ronald Reagan.

VAL WAGNER '47. Val Wagner was a strong-armed tailback for the Tigers in the first years after the war. In 1946, he made a key interception in Princeton's 17-14 upset of a Penn team ranked third in the country. Two years later, he connected on a 61-yard touchdown pass to Cliff Kurrus '51 in a victory over the Quakers before 60,000 fans at Franklin Field.

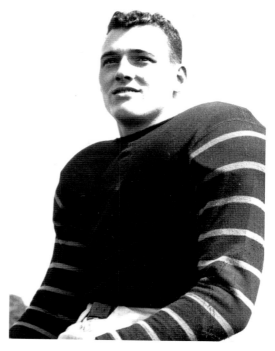

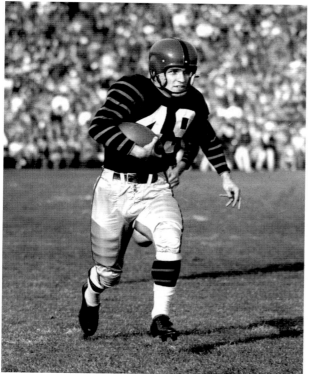

PAUL COWIE '46. Paul Cowie was a track star before he even tried out for football. In 1947, he set a record at the Penn Relays, running the 100-yard dash in 9.7 seconds. Coach Charlie Caldwell first made use of Cowie as a kick returner before switching him to halfback. "He's the people's choice in Tigertown," wrote Allison Danzig in the *New York Times*.

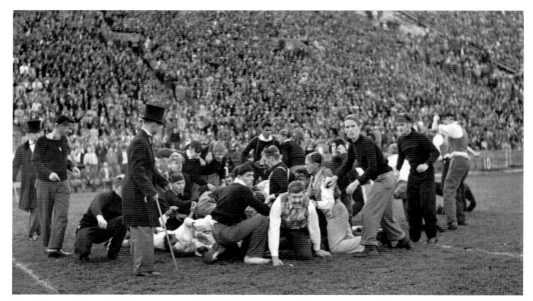

THE FIRST GAME IS REENACTED. In 1946, a group of Princeton and Rutgers students at Palmer Stadium reenact the first intercollegiate football game. The festivities coincided with Princeton's bicentennial that year. Although the teams captured the chaos of the first college football game, the outcome this time was different: the Tigers won their annual meeting, 14-7.

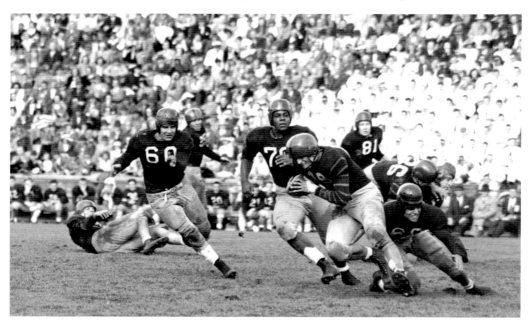

A VICTORY OVER HARVARD. A Princeton receiver, possibly Paul Cowie, makes a gain against Harvard in a 1947 victory over the Crimson. Harvard back Chester Pierce closes in to assist on the tackle. Earlier that season, Pierce became the first African American to play against a white college in the South when the Crimson visited the University of Virginia.

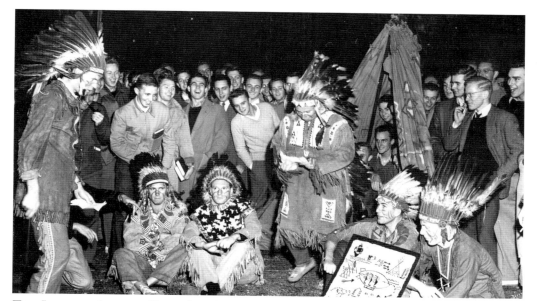

THE INDIANS ATTACK. From the 1920s until 1974, Dartmouth's teams were known as the Indians, not the Big Green. The teams always played in Princeton because the gate receipts were bigger at Palmer Stadium—they did not play each other in Hanover until 1964. Here a group of visiting Dartmouth students stages a powwow before the Tigers' 14-12 victory in 1947.

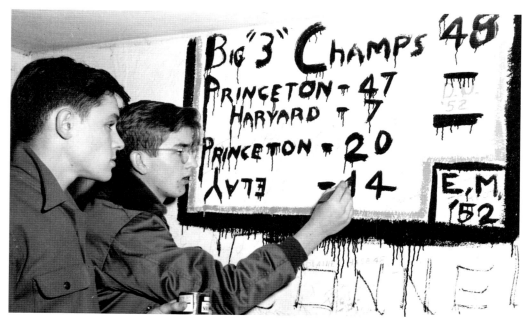

PRINCETON WINS THE BIG THREE CHAMPIONSHIP, 1948. The Tigers went only 4-4 in 1948, but they won the two games that counted most, crushing Harvard, 47-7, and nipping Yale, 20-14. Here a group of students commemorates the achievement with some graffiti. That season set the stage, however, for much greater things to come.

PRINCETON FOOTBALL

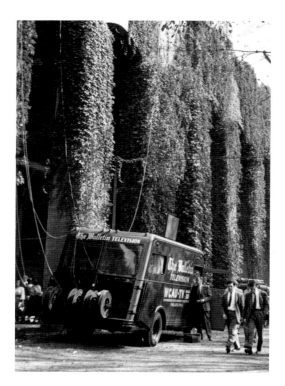

TELEVISION COMES TO PALMER STADIUM.
A Princeton-Columbia baseball game
in 1939 was the first sporting event ever
televised, but Tiger football also made an
early premiere. Television cameras were at
Palmer Stadium at least as early as the 1947
Dartmouth game, and athletic director
Kenneth Fairman '34 reported that the
Princeton Club of New York was "swamped"
with fans watching the 14-12 Tiger victory.

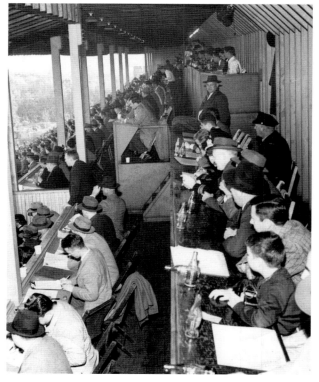

**A CROWDED PRESS BOX AT
PALMER STADIUM.** As late as the
1970s, Princeton football received
extensive media coverage and
game summaries were frequently
the lead story in the New York
and national papers. A new press
box was built atop Palmer Stadium
before World War II, and it was
usually as crowded as the stands
below, as in this shot taken during
the late 1940s. (PUAD.)

THE PRINCETON UNIVERSITY BAND. The Princeton band was formed in 1919 and made its gridiron debut at a 35-0 victory over the University of Maryland the following year. It claims to be the first football band to march on the field at halftime. By the late 1960s, its humor had grown sufficiently irreverent that ABC was reluctant to show the group during its television broadcast.

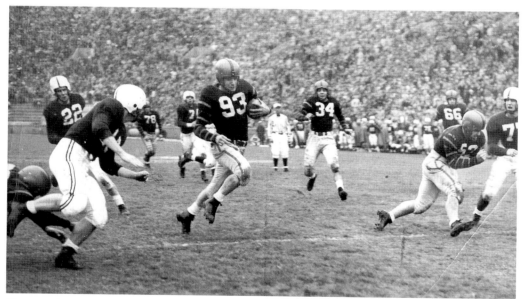

GEORGE SELLA '50. George Sella was team captain and a first team All-American back in 1949. He averaged 6.3 yards per carry as a senior, 6.1 per carry for his career, both school records at the time. A chemical engineering major, he also played basketball and was nicknamed "Cyclone Sella." Like Dick Kazmaier two years later, Sella was drafted by the Chicago Bears but attended Harvard Business School instead.

PRINCETON FOOTBALL

Two Generations of All-Americans. Maintaining a line of tradition that spanned three-quarters of a century, George Sella '50 receives the John Prentiss Poe Trophy in 1949 from two of Poe's brothers, Net (left) and Edgar Allen (right), himself an All-American. Now known as the Poe-Kazmaier Trophy, the award is presented annually to the team member who best exemplifies loyalty, courage, manliness, modesty, perseverance, and fairness.

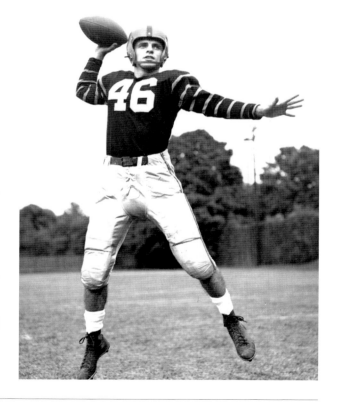

Jake McCandless '51. A tailback and safety, Jake McCandless played on the 1950 championship team but was often overshadowed by his teammate Dick Kazmaier. In 1969, he succeeded Dick Colman as head coach and shared an Ivy League title in his first season. It was McCandless who finally abandoned the single-wing offense, Princeton's longtime signature, in favor of the T formation.

EDDIE ZANFRINI.
Princeton's trainer from 1933 to 1967, Eddie Zanfrini was beloved by a generation of athletes—"one part administrator, one part physician and three parts practicing psychologist," as one person put it. A master motivator, Zanfrini issued Dick Kazmaier's old number, 42, to basketball sensation Bill Bradley when Bradley arrived on campus a decade later. Zanfrini also served as the trainer on three U.S. Olympic teams.

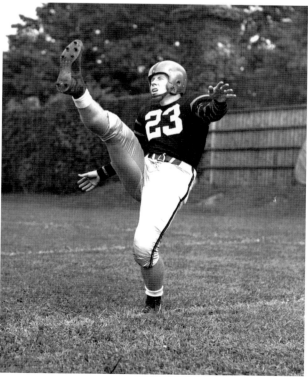

GEORGE CHANDLER '51.
George Chandler captained the undefeated 1950 team, which won the Lambert Trophy and finished the season ranked sixth in the country by the Associated Press. "Possibly no Tiger team has ever dominated the competition the way the 1950 team did," one historian has written. Coach Charlie Caldwell called Chandler, the team's quarterback, the "most underrated" player in the league.

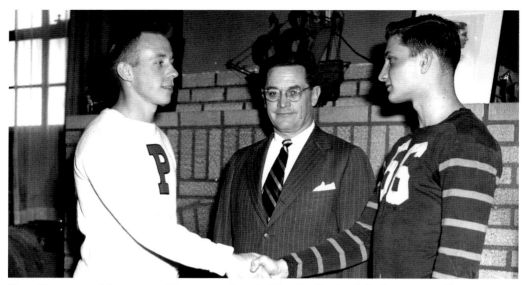

Two Captains Make the Handoff. Coach Charlie Caldwell looks on proudly as captain George Chandler '51 welcomes his successor, David Hickok '52. Chandler, wearing the white captain's sweater, passed along a 13-game winning streak, as well as Princeton's last national championship. Hickok, a linebacker, led his team to another undefeated season and another Lambert Trophy as best team in the East.

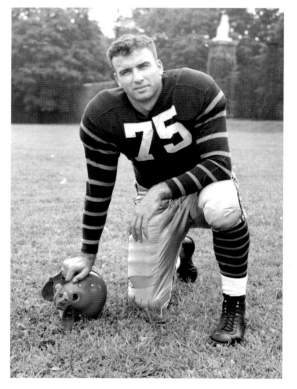

Hollie Donan '51. A leader on and off the field, Hollie Donan, an All-American, was known for rallying his team with inspirational locker room pep talks. He stood six-foot-five-inches tall and weighed 230 pounds. Coach Charlie Caldwell called him the best tackle he had ever seen. Others agreed, as Donan was later elected to the College Football Hall of Fame.

CHARLES CALDWELL '25. Charlie Caldwell turned the single-wing offense into a thing of beauty that could operate out of 24 different formations. Although he played on the 1922 Team of Destiny, he was an even better baseball player whose undergraduate batting average was higher than Lou Gehrig's at Columbia. It was Caldwell, in a way, who made the Iron Horse a star. As a rookie pitcher with the New York Yankees in 1925, Caldwell beaned George Pipp during batting practice. Pipp asked for the day off, Gehrig took his place, and went on to the National Baseball Hall of Fame. Caldwell was the head coach at Williams College for 17 years before returning to Princeton at the end of World War II. The Tigers won nearly 70 percent of their games during his 12 seasons, including two Lambert Trophies. Caldwell died of cancer during the 1957 season.

FOUR PRINCETON CAPTAINS. The captains of four undefeated Princeton teams, each of them a legend, pose together at a team banquet after the 1951 season. They are, from left to right, Melville Dickenson '22, who captained the 1922 Team of Destiny; Arthur Lane '34, who captained the 1933 team; Pepper Constable '36, who led two of Fritz Crisler's greatest teams and captained the 1935 squad; and George Chandler '51, who led the Tigers to the Lambert Trophy in 1950. The Tigers have fielded 26 undefeated teams, 16 of which had perfect records without any ties. Only Yale has produced more.

REDMOND FINNEY '51. Redmond "Reddy" Finney, a star center and linebacker, joined teammates Hollie Donan and Dick Kazmaier as All-Americans in 1950. A standout in the days of the three-sport athlete, he was also an All-American lacrosse player and captained the wrestling team. Finney and Jim Brown, in fact, are the only two men ever to be named All-Americans in two sports in the same year. (Courtesy of Redmond Finney.)

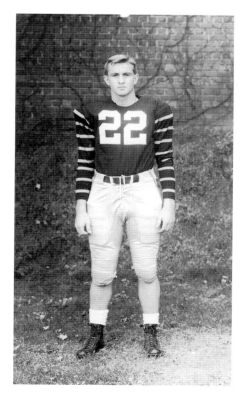

JOHN McGILLICUDDY '52. John McGillicuddy was a defensive back on two Lambert Trophy–winning teams. He was elected president of the Manufacturers Trust Company at the age of 40, one of the youngest people ever to head a major bank. He later orchestrated the largest bank merger in history, played a key role in the federal bailout of Chrysler, and served as an advisor to two presidents. (Courtesy of Constance McGillicuddy.)

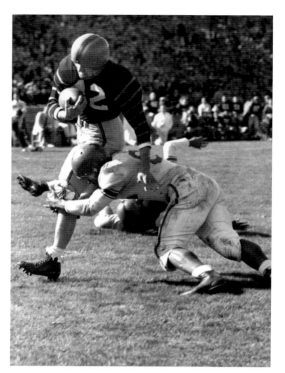

RICHARD KAZMAIER '52. If a vote were taken to determine the greatest Princeton football player of all time, the winner would probably be Dick Kazmaier. In 1951, he won the Heisman Trophy, was named Athlete of the Year by the Associated Press, and had his picture on the cover of *Time* magazine. They called him "a refreshing reminder . . . that winning football is not the monopoly of huge hired hands taking snap courses at football foundries." A triple-threat tailback, Kazmaier rushed for 1,950 yards, threw for 2,400 more, and scored 55 touchdowns during his three-year varsity career. In the 1951 rout of nationally ranked Cornell, Kazmaier passed for three touchdowns, rushed for another two, added a safety, and out-gained the entire Big Red team, 360 yards to 210. His is the only uniform number that Princeton has ever retired.

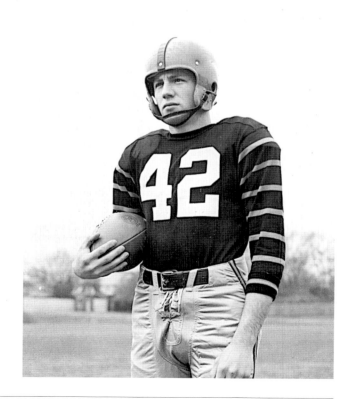

A Game Played in a Hurricane. Weather conditions at Palmer Stadium were never worse than for a 1950 game against Dartmouth, played as Hurricane Flora ravaged the East Coast. Officials had to hold the ball between plays to keep it from blowing away. Only 5,000 people sat through the deluge to witness a 13-7 Tiger victory in conditions the *New York Times* called "so miserable as almost to defy description."

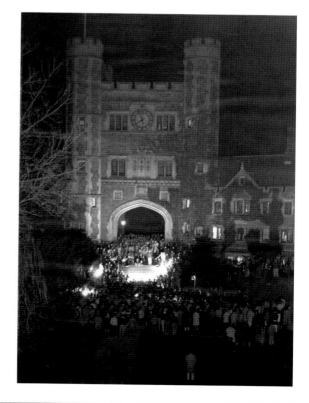

A Pep Rally at Blair Arch. On an increasingly fragmented campus, few activities are better at bringing students together than a home football game. This pep rally was held in November 1951 on the steps of iconic Blair Arch to celebrate winning the Big Three title (and another undefeated season). Students then marched to Cannon Green for the traditional bonfire.

PRINCETON FOOTBALL

FRANK MCPHEE '53. Frank McPhee, a consensus All-American end, captained the 1952 Tiger squad, which finished 8-1. One of the last 60-minute stars, he was also an excellent defensive end who blocked two punts and an extra point in a 53-15 drubbing of Cornell in 1951. He hauled in an 80-yard bomb against Yale in a 27-21 victory as a senior. After graduation, McPhee played briefly for the Chicago Cardinals.

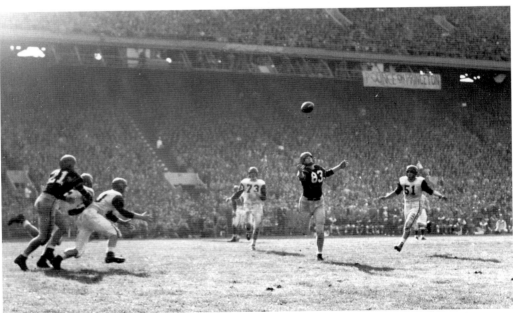

MCPHEE SCORES AGAINST PENN. The rangy McPhee, who stood six-foot-three-inches tall, was also a favorite target for Dick Kazmaier. Here he hauls in a pass for what proved to be the winning touchdown in a 13-7 victory over Penn at Franklin Field in 1951. Contributions such as these put him on Princeton's All-Century team. (PUAD.)

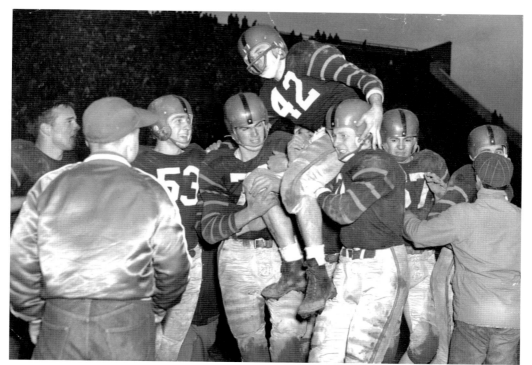

KAZMAIER GOES OUT A WINNER. Teammates carried Kazmaier off the field at the end of his final game, a 13-0 victory against Dartmouth, but it had been a long afternoon. The star back missed most of the game after suffering a broken nose and a concussion on what many called a late hit. Coach Charles Caldwell sent him back into the game to take a final bow before the home crowd.

Clip for KAS folder

KAZMAIER WINS THE HEISMAN TROPHY. In 1951, Dick Kazmaier won the Heisman Trophy by what was then the largest margin in its history, receiving more than four times as many votes as the runner-up, Hank Lauricella of Tennessee. He learned of the honor when he was called into the dean's office, said thank you, then went back to class.

HOLD THAT TIGER. Nassau Hall was named after William of Orange, of the House of Nassau, and so orange was a natural school color. In 1880, Princeton teams began wearing black uniforms with orange stripes, which led fans and writers to start calling them tigers. After a short-lived experiment with a live tiger on the sidelines in 1923, the costumed mascot made its first appearance after World War II.

ROBERT UNGER '54. To Bob Unger fell the unenviable task of trying to step into Dick Kazmaier's shoes after Kazmaier's graduation, but the wingback performed the job very well. A triple threat, he passed (left-handed) for 129 yards and three touchdowns in a 27-21 victory over Yale and then carried the ball on 11 consecutive plays to help run out the clock.

KENNETH FAIRMAN '34. Kenneth Fairman (left, with Charlie Caldwell) won eight varsity letters as an undergraduate and served for 32 years as Princeton's athletic director. In the latter capacity, he oversaw a broad expansion in the university's athletic program, oversaw the construction of Jadwin gymnasium and increased recreational opportunities for all students. He was a strong proponent of the Ivy League.

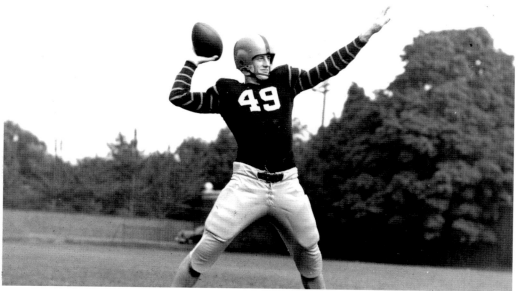

EDGAR JANNOTTA '53. Edgar "Ned" Jannotta was a talented tailback who was named to the All-East team in 1952. He graduated cum laude, earned a master's degree at Harvard Business School, and went on to a long and successful business career. He helped persuade a fellow New Trier High School student, Donald Rumsfeld, to attend Princeton and later managed Rumsfeld's successful campaign for a congressional seat in 1962.

PRINCETON FOOTBALL

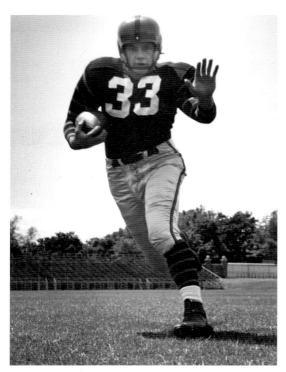

HOMER SMITH '54. Homer Smith started as a linebacker but was so fast and strong—he was a hurdler and long-jumper—that he was moved to fullback and graduated holding several team records, including those for most yards in a game (273, against Harvard) and longest run from scrimmage (93 yards, against Yale). Smith became a successful coach and coordinator in college and the NFL and also attended Harvard Divinity School.

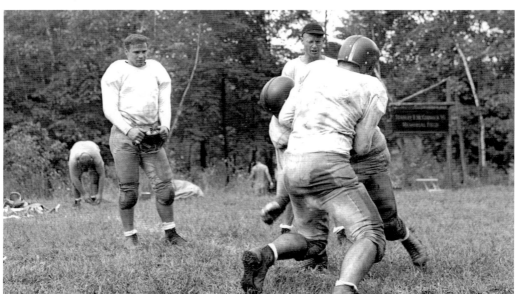

AUGUSTS AT BLAIRSTOWN. For years, Princeton football teams learned camaraderie and hard work in preseason training sessions at the Princeton Summer Camp at Blairstown, New Jersey. "It was remote, it was intimate, and when you first came in it could be intimidating," Stas Maliszewski '66 remembered years later. "It was a special experience." Here Dick Colman (wearing glasses), then an assistant coach, teaches proper blocking technique.

CALDWELL AND HEISMAN: 1941–1957

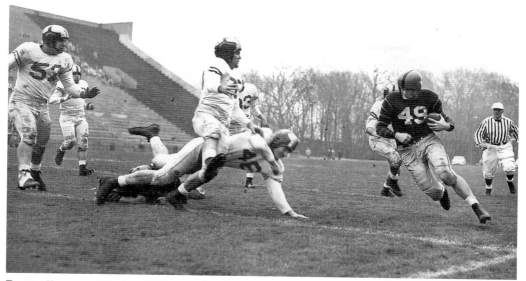

ROYCE FLIPPIN '56. An All-East tailback, Royce Flippin was the Yale Killer, scoring 11 of the 12 touchdowns his team managed against the Elis in one year with the freshmen and three with the varsity. As a sophomore, he nearly broke Dick Kazmaier's record for total offense but a series of injuries limited his effectiveness afterwards. Flippin later served as the athletic director at Princeton and at MIT. (PUAD.)

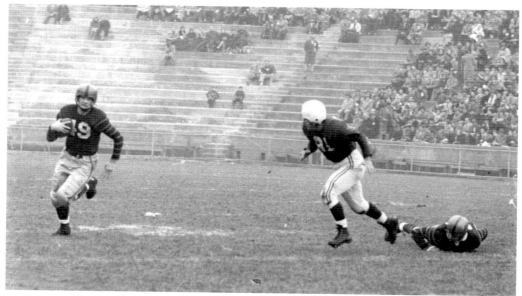

A VICTORY OVER DARTMOUTH. Although elected captain, Royce Flippin missed most of his senior season after Syracuse great Jim Brown injured Flippin's knee during a scrimmage. He returned to action in time for his usual heroics against Yale, then capped his career in a 6-3 victory over Dartmouth during a snowstorm. Flippin's fake enabled Bill Agnew '56 to score the winning touchdown. (PUAD.)

PRINCETON FOOTBALL

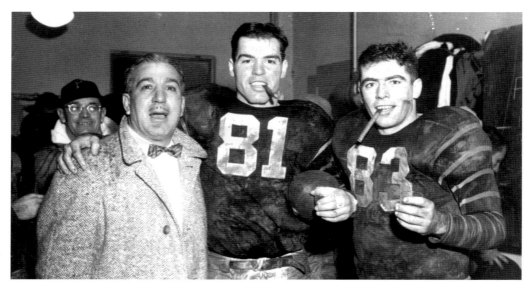

A VICTORY CIGAR. The 1955 season was the last before the Presidents' Agreement took effect, creating the Ivy League. Even so, the Tigers were already playing all of their soon-to-be Ivy rivals. They closed the season with a dramatic victory against Dartmouth. Joe DiRenzo (81) and Ben Spinelli (83) celebrate with cigars in the locker room afterwards, as coach Charlie Caldwell looks on from the background.

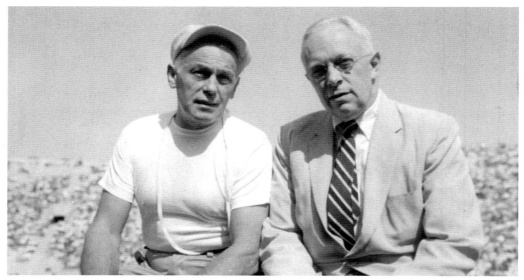

ASA BUSHNELL '21. A lifelong sportsman, Asa Bushnell (right, with trainer Eddie Zanfrini) was commissioner of the Eastern College Athletic Conference from 1938 until 1970. He also served as Princeton's athletic director and on the board of the U.S. Olympic Committee. The Asa Bushnell Cup is presented to the Ivy League football player "who displays outstanding qualities of leadership, competitive spirit, contribution to the team, and accomplishments on the field." (Courtesy of Asa Bushnell III.)

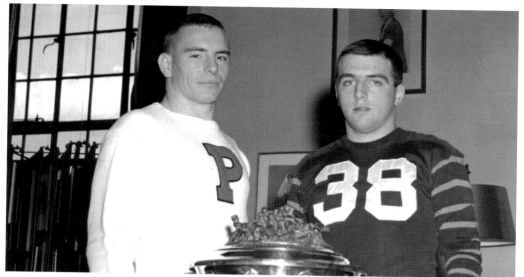

THE FIRST IVY LEAGUE CHAMPIONSHIP. Captain John Sapoch '58, left, passes the Ivy League trophy to his successor, Fred Tiley '59. Sapoch, a quarterback, and Tiley, a fullback, were both named second team All-Ivy in 1957 as Princeton won its first title in the newly established Ivy League. At the end of Sapoch's final game, against Dartmouth, his teammates carried him off the field on their shoulders.

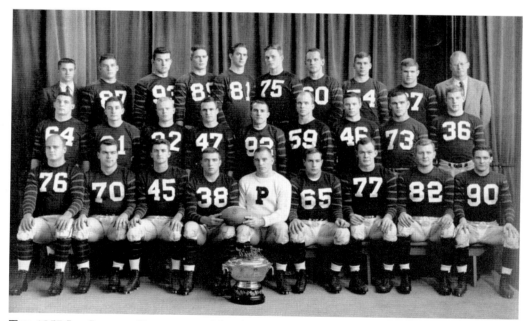

THE 1957 IVY LEAGUE CHAMPIONS. The glory of winning Princeton's first Ivy League title was dimmed on November 1, 1957, when coach Charlie Caldwell died of cancer. The team learned the news in Providence as they prepared for a game against Brown the following day. Assistant coach Dick Colman, who had been filling in during Caldwell's illness, was named head coach.

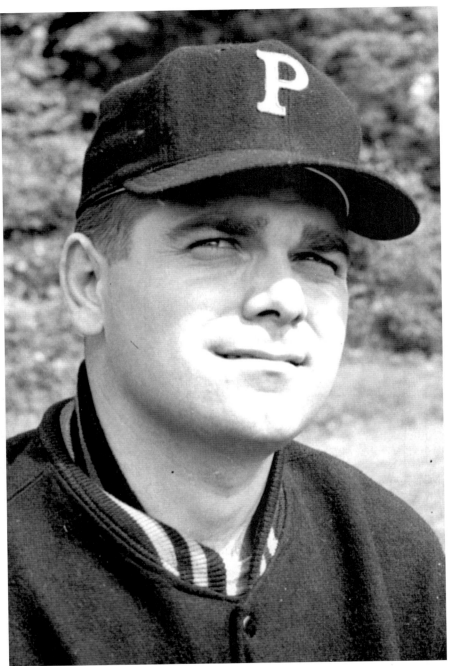

Robert Casciola '58. Bob Casciola contributed to Princeton football as a player (he was an All-Ivy tackle in 1957), as head coach from 1973 to 1977, as a television analyst, and even as a recruiter. As a Tiger assistant in 1960, he recruited future-hall-of-famer Cosmo Iacavazzi. Casciola later became chief operating officer of the NBA's New Jersey Nets and president of the National Football Foundation.

CALDWELL AND HEISMAN: 1941–1957

5

IVY GLORY

1958–1982

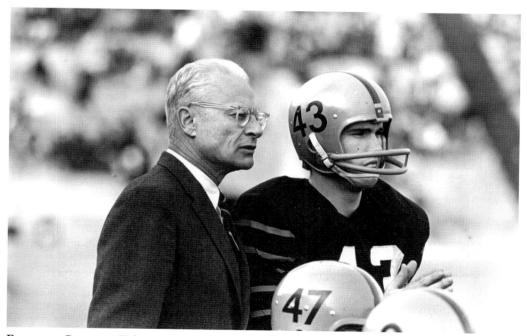

RICHARD COLMAN. Taking over the head coaching job under difficult circumstances in 1957, Dick Colman nevertheless continued the string of Tiger successes begun by Charlie Caldwell, and also continued the team's trademark single-wing offense. He had been a star at Williams College, lettering in six sports and later coaching there. Colman won four Ivy League titles and retired with exactly the same winning percentage (.694) as Caldwell's.

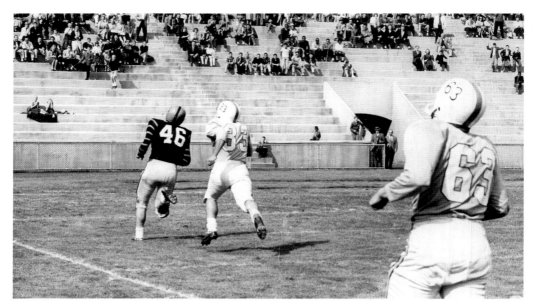

DAN SACHS '60. Opponents usually saw only the back of Dan Sachs's jersey, as in this touchdown run against Columbia in 1958. He was an All-Ivy selection in 1957, a French major who graduated Phi Beta Kappa and won a Rhodes Scholarship. He was diagnosed with cancer after his first year at Harvard Law School and died at the age of 28. (PUAD.)

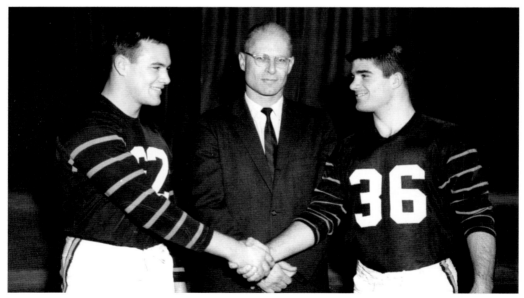

A MEETING OF CAPTAINS. Donald Kornrumpf '61, right, a fullback and captain of the 1960 Tiger squad, greets his successor, linebacker Ed Weihenmayer '62, as coach Dick Colman looks on. Weihenmayer became a Marine fighter pilot during the Vietnam War. He later worked with his son, who became the first blind person to climb Mount Everest, producing a book and film about the experience.

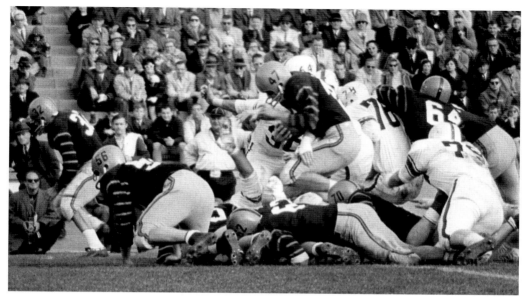

HUGH MACMILLAN '64. Tailback Hugh MacMillan plows ahead in a 27-7 victory over Yale in 1963, en route to an Ivy League title. Although often overshadowed by his backfield mate Cosmo Iacavazzi '65, MacMillan rushed for 131 yards against Brown and returned a punt 92 yards against Colgate University. The season finale against Dartmouth was postponed for a week because of the assassination of Pres. John F. Kennedy. (PUAD.)

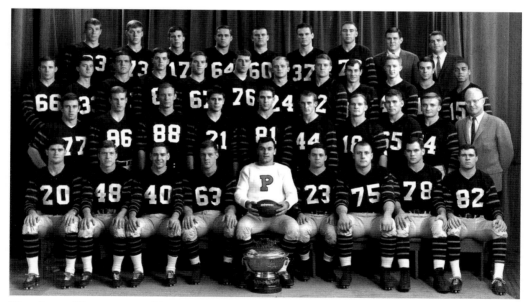

THE LAST UNDEFEATED TEAM. Princeton's 1964 team was its last to post a perfect record. Six members of the team were named first team All-Ivy, and two, back Cosmo Iacavazzi '65 (in white sweater) and guard Stas Maliszewski '66 (third row, third from left), were named All-Americans. Iacavazzi finished the season with 909 yards and 14 touchdowns, both school records at the time.

PRINCETON FOOTBALL

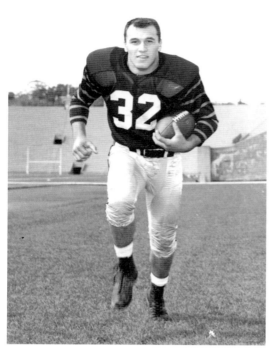

COSMO IACAVAZZI '65. Possibly Princeton's greatest running back, Cosmo Iacavazzi was an All-American in 1964. He also finished ninth in balloting for the Heisman Trophy. Iacavazzi had been recruited by more than 50 colleges, and when he chose Princeton, assistant coach Jake McCandless was so excited that he drove in his bathrobe to tell coach Dick Colman. Although the 1964 season brought the return of two-platoon football, Iacavazzi continued to play both ways. For his career, Iacavazzi rushed for 1,895 yards, at the time second only to Dick Kazmaier. "If undefeated Princeton had started a rodeo steer at fullback instead of Iacavazzi," the *New York Times* wrote about a win over the Quakers, "it's doubtful if Penn's harried defenders would have had a harder time making the stops." In 2003, he was elected to the College Football Hall of Fame.

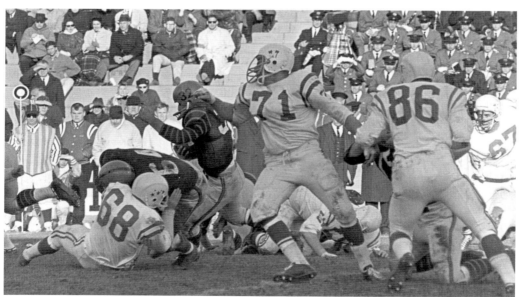

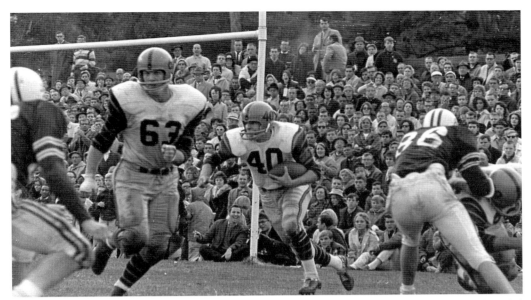

THE FIRST TRIP TO HANOVER. Although the Tigers had played Dartmouth since 1897, they did not make their first trip to Hanover until 1964. This was a revenge game, as Princeton had lost to Dartmouth the previous year on the way to an Ivy League crown. There was no suspense in 1964: the Tigers rolled, 37-7. Here Don McKay '65 follows a block upfield by Paul Savidge '66. (PUAD.)

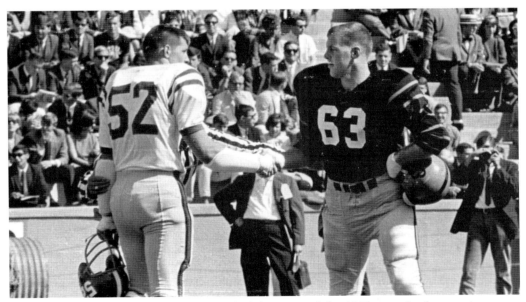

PAUL SAVIDGE '66. George Paul Savidge (right) captained the 1965 team. In the opening game, he walked to midfield and greeted the Rutgers captain, George Peter Savidge, his fraternal twin. When the rules were changed before the 1964 season to allow unlimited substitution, Paul switched to defense. *Sports Illustrated* called Paul Savidge and Stas Maliszewski '66 "a couple of off-season wrestlers who weigh 215 pounds apiece and move with devastating efficiency." (PUAD.)

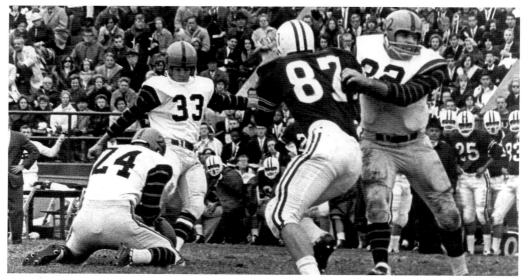

CHARLIE GOGOLAK '66. Charlie Gogolak and his brother Peter, who played for Cornell, revolutionized football as the first soccer-style kickers. They had been born in Hungary and had emigrated to America with their parents after the 1956 uprising. He kicked six field goals and two extra points in a game against Rutgers. An All-American in 1965, Gogolak was a first-round draft pick of the Washington Redskins. (PUAD.)

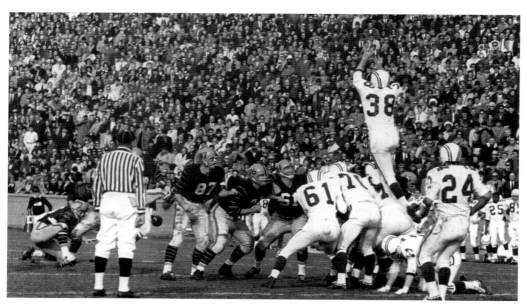

HOW TO STOP GOGOLAK? Cornell tried building a human pyramid. It did not work: Gogolak kicked a 54-yard field goal against them, which remains the modern Princeton record. Dartmouth had a defensive back, wearing cross country shoes, leapfrog his linemen to block the kick in midair. He was offside the first time they tried it, but Gogolak missed his second attempt, shown here. (Courtesy of Dartmouth College Sports Information.)

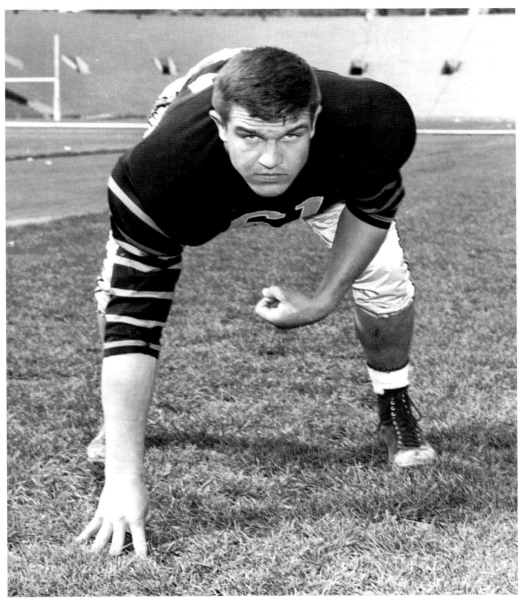

STANISLAW MALISZEWSKI '66. Stanislaw Maliszewski, an All-American in 1964 and 1965 (a consensus choice in 1965) and perhaps Princeton's greatest linebacker, was born in Belarus, and lived for a while in a displaced persons' camp after World War II. After his parents emigrated to Iowa, Maliszewski passed up a chance to play for the University of Notre Dame in order to attend Princeton, where he majored in philosophy and wrote his thesis on "The Existence of God in Hume and Kant." His philosophy on the field, however, was to create havoc with opposing offenses. In 1964, he anchored a defense that allowed only six touchdowns in nine games and recorded four consecutive shutouts. Maliszewski played professionally for the Baltimore Colts and used his earnings to pay his way through Harvard Business School.

RON LANDECK '66. An outstanding single-wing tailback, Ron Landeck was typical of the blue-chip recruits who graced Princeton teams in the 1960s. He was recruited by so many schools that he stopped counting after 80 and turned down Ohio State's Woody Hayes, among others, to play for Dick Colman. Landeck showed how potent a single-wing offense could still be, tossing four touchdown passes against Brown in 1965. (PUAD.)

HAYWARD GIPSON '67. In 1964, the year congress passed the Civil Rights Act, Hayward Gipson became the first African American to earn a football letter at Princeton. Gipson was a talented defensive back and track athlete, who recovered a pair of fourth-quarter fumbles in a 7-0 victory over Cornell in 1966 that clinched the Ivy title. He later became a successful business executive. (Photograph by Alan W. Richards.)

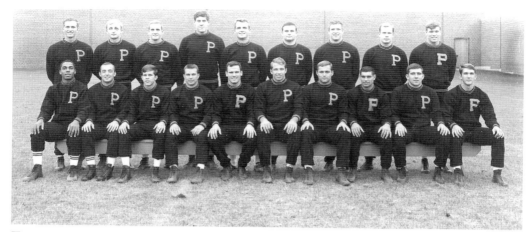

THE 1966 CINDERELLA IVY LEAGUE CHAMPIONS. After back-to-back Ivy League titles in 1963 and 1964, the Tigers stumbled in 1965 and seemed ordinary four weeks into the 1966 season, with a 2-2 record. Something clicked, though, and gritty wins over Harvard (18-14), Yale (13-7), and Cornell (7-0) gave them a one-third share of the championship, the last under Dick Colman and the single-wing offense. (PUAD.)

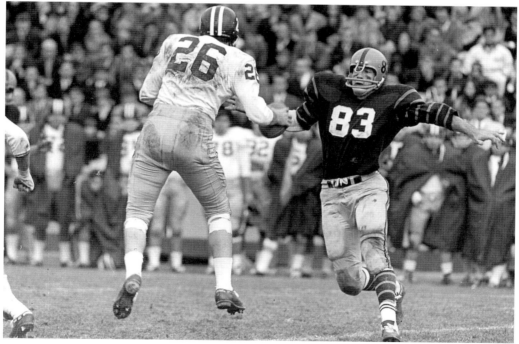

WALT KOZUMBO '67. Walt Kozumbo captained the 1966 Ivy League champions and was an All-Ivy defensive end. Perhaps his greatest performance came in the Harvard game when he stuffed Crimson fullback Tom Choquette on fourth and inches to preserve an 18-14 upset victory. The following week, he blocked a punt against Yale. Kozumbo earned a doctorate degree and became a program manager for the U.S. Air Force. (Photograph by Randall Hagadorn, PUAD.)

ROBERT WEBER '68. Robert Weber was one of the last of Princeton's single-wing tailbacks, a demanding position that required speed and agility. He threw for two touchdowns and ran for another in a 28-14 victory over Columbia in 1967 and scored three times in a 28-0 shutout over Colgate University, amassing 152 yards. (PUAD.)

RICHARD BRACKEN '69. The captain of Dick Colman's last team, Richard Bracken, a native of Winnipeg, had been named the outstanding freshman football player in 1965. He quickly made good on that promise, engineering a 51-yard drive late in the game and scoring the only touchdown in a 7-0 victory over Cornell that gave the Tigers a share of the 1966 Ivy title. (Photograph by Randall Hagadorn, PUAD.)

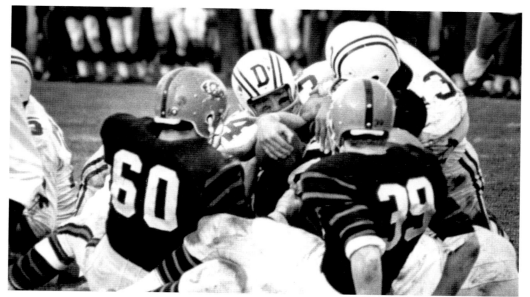

MICHAEL GUERIN '70. Michael Guerin (60) was a first team All-Ivy selection at guard in 1968 and again in 1969, spanning the transition from Dick Colman's single-wing offense to Jake McCandless's T formation. His blocks opened holes for two powerful running backs, Ellis Moore '70 and Hank Bjorklund '72. (PUAD.)

THE 1969 CENTENNIAL GAME. On September 27, 1969, Princeton and Rutgers met again in New Brunswick to mark the 100th anniversary of the first intercollegiate football game. Princeton won a reenactment that students from the two schools staged before the kickoff. Inside the stadium, however, despite this gain by Robinson Bordley '70, the Scarlet Knights dominated the centennial contest, 29-0. (PUAD.)

ELLIS MOORE '70. In the modern era, no Tiger has ever enjoyed a bigger day than Ellis Moore did against Harvard in 1967. The fullback rushed for five touchdowns in a 45-7 pounding of the Crimson. His 30-point game remains a school record. Moore later captained the 1969 Ivy League championship team in the first season for Jake McCandless as head coach. (PUAD.)

KEITH MAUNEY '70. Keith Mauney (21), a talented defensive back during the late 1960s, compiled an impressive gridiron record. He was twice selected to the All-Ivy team and to the All-Ivy Silver Anniversary team, selected in 1981 by writers, broadcasters, coaches, and administrators. As a senior, he also won the Poe-Kazmaier Trophy as outstanding member of the team. (PUAD.)

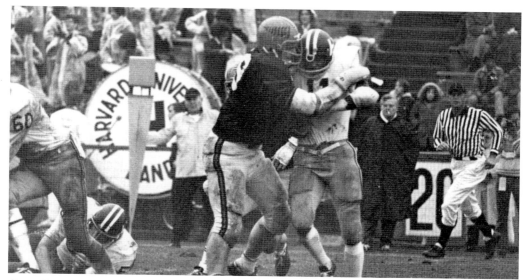

CARL BARISICH '73. The Tigers did not have a successful season in 1972, but defensive tackle Carl Barisich delivered an outstanding individual performance in a 10-7 upset of Harvard. "All he did," Crimson coach Joe Restic muttered after the game, "was keep us from running off tackle—either side." The Palmer Stadium crowd gave Barisich a standing ovation. He went on to play nine seasons for four NFL teams. (PUAD.)

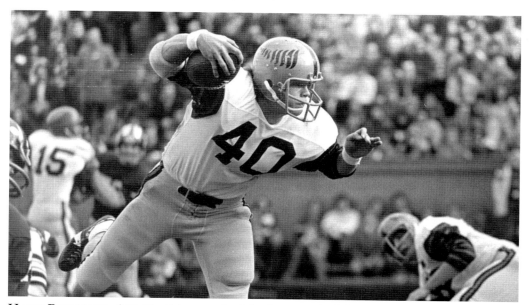

HANK BJORKLUND '72. No Princeton back had ever rushed for 1,000 yards in a season until Hank Bjorklund did it in 1970. The previous year, as a sophomore, he rushed for 132 yards and scored three touchdowns in an upset of an undefeated Dartmouth team. Such performances led to two All-Ivy selections and drew attention from the NFL. Bjorklund played three seasons for the New York Jets. (PUAD.)

PRINCETON FOOTBALL

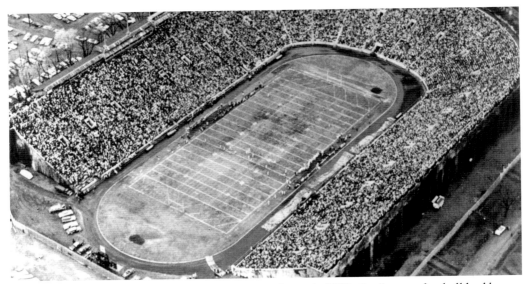

CROWDS STILL FLOCK TO PALMER STADIUM. By the early 1970s, Ivy League football had begun to lose national attention, but the Tigers could still draw large crowds for big games. The New York Giants considered playing at Palmer Stadium while their new stadium was being built in the Meadowlands, but chose the Yale Bowl instead. Nevertheless, the Giants and New York Jets did play some preseason games in Princeton.

HENRY TOWNS. Henry Towns was Princeton's equipment manager from 1970 through 1993, serving under four university presidents and six head football coaches. Known affectionately as "Professor," he had played football for Eddie Robinson at Grambling State University and told a local paper that he tried to "treat everybody the same, whether you were the star or the last person on the team." The Hank Towns Award is given to the senior who has mentored younger athletes. (PUAD.)

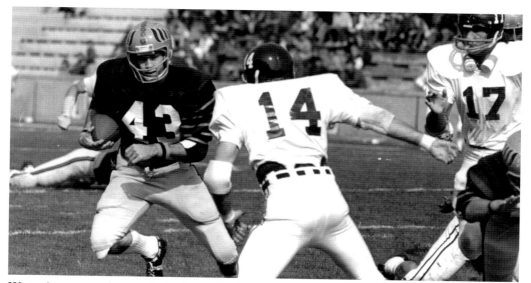

WALT SNICKENBERGER '75. Walt Snickenberger was a multisports star, by then a dying breed. His football accomplishments were obvious: he rushed for 2,241 yards in his career, second most in school history at the time; was the first Tiger to win the Bushnell Cup as Ivy League player of the year; and was a third team All-American. But he also captained the ice hockey team and drew professional scouts.

RON BEIBLE '76. The switch to a modern-style offense made the quarterback position much more important and Ron Beible rewrote the Princeton record book during his three varsity seasons. The civil engineering major threw for 3,662 yards in his career, breaking Dave Allerdice's record, yet threw only 28 interceptions in 592 passing attempts. In 1975, he received one of 33 NCAA postgraduate scholarships.

ROBERT EHRLICH '79. Robert Ehrlich was a standout linebacker. He was elected team captain in 1978 but a knee injury ruined the season. The next step was law school at Wake Forest University, followed eventually by election to the House of Representatives. In 2002, with backing from many of his former teammates, Ehrlich was elected governor of Maryland. (PUAD.)

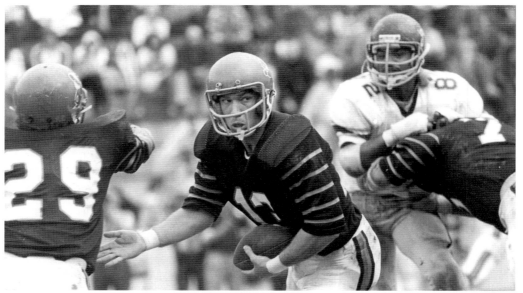

MARK LOCKENMEYER '81. Although he quarterbacked the Tigers to a winning record in 1980, and accounted for 327 yards of total offense in a win over Dartmouth, Mark Lockenmeyer is in the Ivy League record books as a baseball player. As a sophomore, he posted a minuscule earned run average of 0.33, the lowest mark in league history. He was later drafted by the Detroit Tigers. (Photograph by Action Sports, PUAD.)

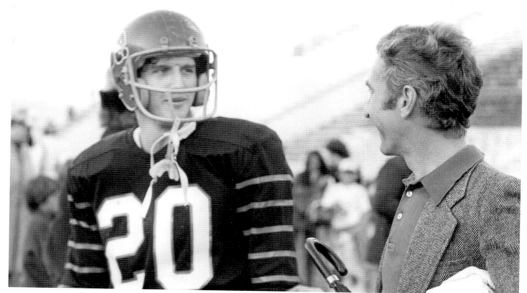

CRIS CRISSY '81. The New England Patriots selected Cris Crissy as a defensive back, but he had starred at two offensive positions for Princeton. His 3,008 total yards are seventh most in school history and he caught 11 passes for 112 yards against Columbia in 1980. He was elected to the All-Ivy team in 1978 (as a back) and in 1980 (as a receiver). (Photograph by Action Sports, PUAD.)

JON SCHULTHEIS '83. The son of two ministers, and named for another, it is not surprising that Jonathan Edwards Schultheis joined the church. In college, Schultheis was a crushing guard who was named the Tigers' cocaptain in 1982. The Philadelphia Eagles drafted him, but Schultheis had never played on Sundays and refused to do so in the NFL. (Photograph by C. W. Pack, PUAD.)

PRINCETON FOOTBALL

DEREK GRAHAM '84. Derek Graham caught 15 passes for 278 yards in a 1981 upset of Yale, the Tigers' first win over the Elis since 1966. But it was the catch Graham did not make that proved the most controversial. With nine seconds left, Yale was called for interference on this pass in the end zone, giving the Tigers the ball at the one-yard line. (Photograph by Action Sports, PUAD.)

BOB HOLLY '82. Bob Holly's plunge gave Princeton a thrilling 35-31 victory over Yale in 1981, a game that has been called the greatest ever played in Palmer Stadium. *Sports Illustrated* named Holly offensive player of the week on the strength of his 36 completions and 501 passing yards. Drafted by the Washington Redskins, Holly won a Super Bowl ring as a backup the following season. (Photograph by Action Sports.)

6

RECENT YEARS

1983 – 2008

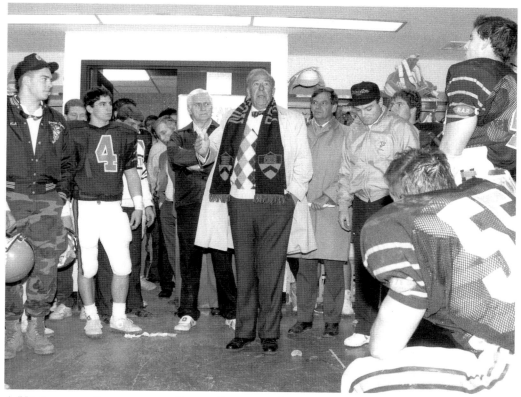

A VISIT BY THE SECRETARY OF STATE. Secretary of State George Shultz '42, a former Princeton player himself, delivered some inspirational words in the Tiger locker room after the 1987 Yale game. Princeton and the rest of the Ivy League moved to the new Division I-AA at the start of the 1982 season, closing one long chapter in their long and storied history and opening another. (PUAD.)

KEVIN GUTHRIE '84. The most prolific receiver in Princeton history, Kevin Guthrie set school records for most receptions in a career, most receptions in a season, and most receptions in a game. In fact, four of the top 10 receiving games in Tiger history are his, including a 1983 contest against Bucknell University in which he had 15 receptions for 200 yards. Guthrie was also a two-time academic All-American. (PUAD.)

DOUG BUTLER '86. The Ivy League's move to Division I-AA did not keep *Sports Illustrated* from noticing when sophomore Doug Butler completed 32 of 53 passes for 469 yards in a 1983 win over Lafayette. The magazine named him its offensive player of the week. Butler holds 16 Princeton passing records, including those for most touchdown passes in a career, season, and game.

STEVE TOSCHES. Steve Tosches became Princeton's head coach under tragic circumstances when Ron Rogerson, who had led the team for two years, died suddenly just weeks before the start of the 1987 season. During 13 seasons under Tosches's leadership, however, the Tigers returned to the Ivy League's front ranks, posting winning records in eight of his first nine years and winning three league titles. (PUAD.)

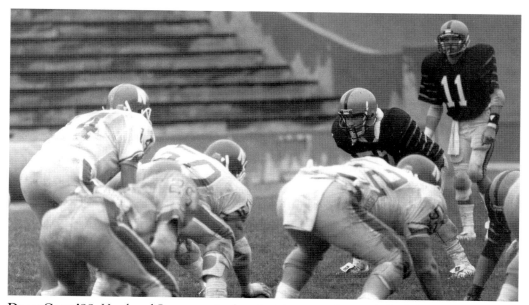

DEAN CAIN '88. He played Superman in the television series *Lois and Clark*, but Dean Cain (11) was also a super safety for the Tigers. He turned down 17 athletic scholarships to attend Princeton and intercepted 23 passes during his career, 12 during the 1987 season—both school records. He also captained the volleyball team. The Buffalo Bills signed him, but an injury during training camp sent Cain to Hollywood instead. (PUAD.)

PRINCETON FOOTBALL

ANTHONY DiTOMMASO '86.

Anthony DiTommaso, a linebacker, shown here on the left with cocaptain Jim Petrucci, was twice named first team All-Ivy. A ferocious tackler, he led the team in both his junior and senior years. DiTommaso had 19 tackles and recovered a fumble in an opening-game victory over Dartmouth in 1985, winning player of the week honors from the Eastern College Athletic Conference. He is currently president of the Princeton Football Association. (PUAD.)

THE GARRETT BROTHERS. Columbia's loss was Princeton's gain. When the Lions fired coach Jim Garrett after the 1985 season, his three sons—from left to right, Judd '90, Jason '89, and John '88—decided to go to Princeton instead. All three were named to All-Ivy squads and Jason won the Asa Bushnell Cup as Ivy player of the year in 1988. Jason later won two Super Bowl rings with the Dallas Cowboys.

A WIN OVER COLUMBIA, 1987. Princeton officials issued 120 press credentials for the 1987 Columbia game, as the national media descended on Palmer Stadium to see if the Lions would break the NCAA Division I record for most consecutive losses. They did. Judd Garrett, shown here, scored three touchdowns and Jason Garrett passed for 173 yards in a 38-8 Tiger victory. (PUAD.)

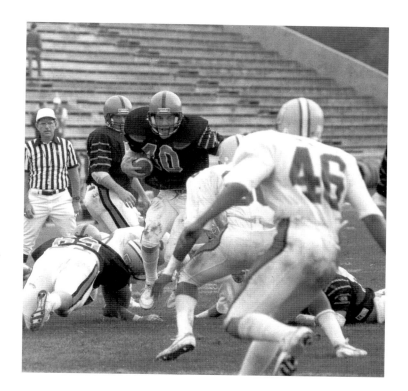

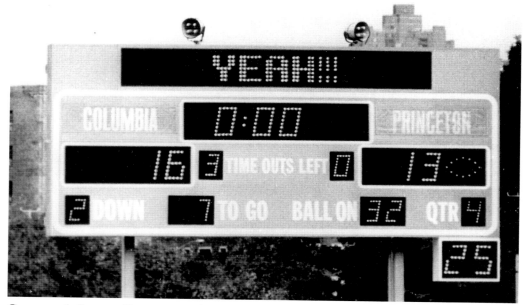

COLUMBIA'S STREAK ENDS, 1988. One year later, it was the Tigers' turn to be on the losing side as the Lions prevailed, 16-13, in Wien Stadium to snap a losing skid that had grown to 44 games. Jason Garrett threw for 201 yards and Judd Garrett ran for 116 more, but it was not enough. "Columbia Wins! That's Right, Wins!" the *New York Times* crowed. (PUAD.)

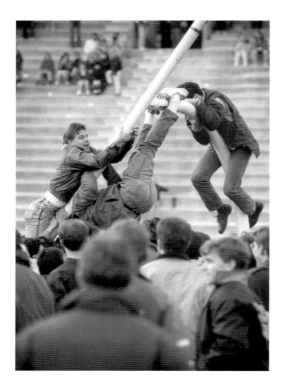

THE GOALPOSTS COME DOWN. Judd Garrett rushed for a then-record 1,347 yards and won the Asa Bushnell Cup in 1989 as Princeton won its first Ivy League championship in 20 years. The Tigers clinched a share of the crown with a decisive 21-7 victory over Cornell in the season's final game. Joyful Tiger fans pulled down the Palmer Stadium goalposts as souvenirs. (PUAD.)

MICHAEL LERCH '93. A true deep threat, Michael Lerch caught four touchdown passes in a 1991 victory over Brown, including a 90-yard bomb from Chad Roghair '92. He also set Division I-AA marks for receiving yards in a game and for all-purpose yardage. He was a key player on the Tigers' 1992 Ivy League championship team, sometimes playing defense as well, and received a vote in the Heisman Trophy balloting. (PUAD.)

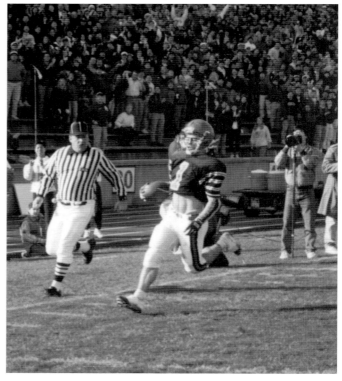

KEITH ELIAS '94. Perhaps Princeton's greatest running back of the post-single-wing era, Keith Elias (20) was a tough, hard-nosed player, adding his own Mohawk and sunglasses-wearing flair. He graduated holding 21 Tiger records and four Division I-AA records. During the 1992 Ivy League championship season, Elias rushed for 299 yards against Lafayette, then following it up with a 273-yard game against Lehigh University the following week. Such achievements led to two first team All-America selections and his selection as the 1993 Ivy League player of the year. He also finished second in voting for the Walter Payton Award as the outstanding player in all of Division I-AA. A history major as an undergraduate, Elias also played two seasons for the Indianapolis Colts. (PUAD.)

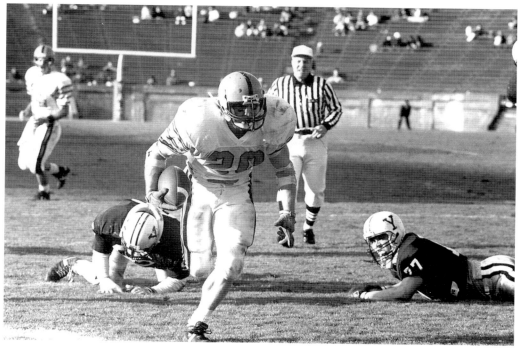

THE 1995 IVY LEAGUE CHAMPIONS. It was snowing so hard in Hanover that it was impossible for Princeton players on one sideline to see Dartmouth players across the field. Trailing 10-7 in the fourth quarter, quarterback Brock Harvey '96 scrambled 18 yards to the one-yard line. Alex Sierk '99 kicked the short field goal and the 10-10 tie gave the Tigers their first outright Ivy League title since 1964. (PUAD.)

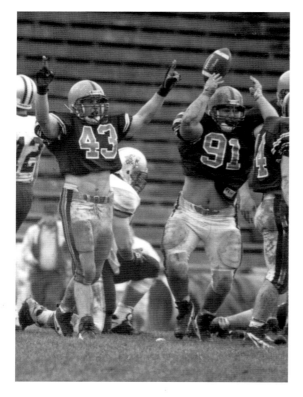

DAVID PATTERSON '96. Linebacker Dave Patterson (43) led the Ivy League with 130 tackles in 1994, the most in league history, and almost equaled the mark in 1995 with 129. But the Tiger team captain did win the league championship in 1995 as well as the Asa Bushnell Cup as most valuable player. He was only the fourth defensive player to earn the honor. (PUAD.)

MATT EVANS '99. "We have Matt Evans, which is wonderful," coach Steve Tosches said before the 1998 season, "But I don't really want to see Matt Evans on the field that much." Punters aren't always welcome, but the first team All-Ivy selection did his job excellently whenever called upon. He averaged 40.8 yards per punt over his career and 49.2 in a single game against Fordham University in 1997.

ROGER HUGHES. Roger Hughes built his reputation during eight seasons as offensive coordinator at Dartmouth, where he was credited with building Jay Fiedler into an NFL quarterback. Moving to Princeton in 2000, Hughes improved the Tigers' winning percentage in six of his first eight seasons. In 2006, he took a team picked to finish sixth and led them to an Ivy championship and their best record in 42 years. (PUAD.)

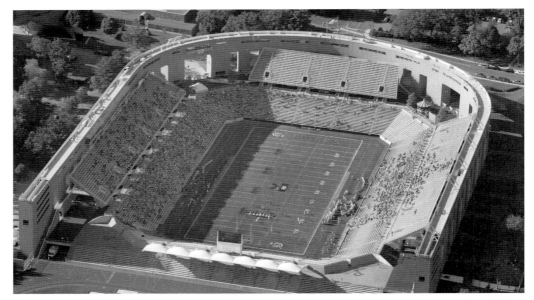

PRINCETON STADIUM. By the mid-1990s, Palmer Stadium was showing its age. It was demolished after the 1996 season and the Tigers played their entire 1997 schedule on the road. But the following year they opened their new home, built on the same site, although with modern amenities and seats only 17 feet from the end zone. Lighting also enabled Princeton to play night games for the first time. (PUAD.)

DENNIS NORMAN '01. Dennis Norman, a powerful center, is one of only four Tigers to be named first team All-Ivy three times. Illustrating his versatility, he was also twice selected first-team All-Ivy in track, won the discus in the Heptagonal championships, and majored in computer science. The Seattle Seahawks grabbed Norman in the 2001 draft and he has played eight seasons in the NFL. (Photograph by Beverly Schaefer, PUAD.)

ROSS TUCKER '01. Ross Tucker played for five NFL teams during a six-year professional career. That followed an All-Ivy selection in 2000 and two selections as an academic All-American. He started all four years, first on the defensive line before being moved to guard. Playing on both sides of the interview table, as well, Tucker has written a blog for *Sports Illustrated*. (Photograph by Beverly Schaefer, PUAD.)

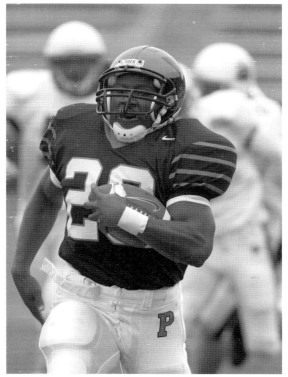

CAMERON ATKINSON '03. Ivy League players pride themselves on shining in the classroom as well as on the field. Cameron Atkinson's playing statistics speak for themselves: he is Princeton's third leading rusher all time. He also majored in chemistry, tutored his teammates in math, spoke German, and recited poetry to himself before games. He rushed for 233 yards against Dartmouth in 2002. (Photograph by Beverly Schaefer, PUAD.)

DAVID SPLITHOFF '04. David Splithoff was one of the most accurate passers in Ivy League history, completing more than 60 percent of his attempts. He could score on the ground too, accounting for four touchdowns in a 2001 rout of Columbia, two passing and two more rushing. In 2000, Splithoff became the first freshman in team history to start at quarterback. (Photograph by Beverly Schaefer, PUAD.)

ZAK KEASEY '05. A two-time first team All-Ivy linebacker, Zak Keasey won the Poe-Kazmaier Trophy in 2004 as the Tigers' outstanding player. He twice recorded 20 tackles in a game during the 2004 season. Keasey signed with the Washington Redskins, switched exclusively to fullback, and became a starter for the San Francisco 49ers during the 2008 season. (Photograph by Beverly Schaefer, PUAD.)

JAY MCCAREINS '06. Jay McCareins was an outstanding defensive back, who intercepted 18 passes in his career and returned a missed field goal 100 yards against Dartmouth in 2005. He also excelled as a kick returner. His 93-yard return proved the margin of victory in a 27-24 win over Harvard. McCareins was named a Division I-AA All-American in 2004. (Photograph by Beverly Schaefer, PUAD.)

DEREK JAVARONE '06. In 2005, Derek Javarone booted a 35-yard field goal to beat Cornell in overtime, a victory that put the Tigers in the thick of the Ivy race and established a new Ivy League record for most career field goals. Against Columbia, he accounted for 19 points (five field goals and four extra points), a single game total second only to Charlie Gogolak's. (Photograph by Beverly Schaefer, PUAD.)

WILLIAM POWERS '79. For 137 years, the Princeton Tigers played their home games on grass. That changed before the start of the 2007 season with the installation of a new FieldTurf surface, given by Bill Powers, shown here, who was an All-Ivy punter in 1978. (Photograph by W. L. Allen, PUAD.)

THE 2006 IVY LEAGUE CHAMPIONS. The Tigers were down by 14 at halftime against Yale, but a stirring comeback gave them a 34-31 victory and a shot at their first Ivy League title in 12 years, which they clinched the following week. The big play was a 57-yard bomb to Brian Brigham '07 that put the Tigers ahead for good and stunned the Elis. (Photograph by Beverly Schaefer, PUAD.)

JEFF TERRELL '07. Jeff Terrell directed Princeton's run to the 2006 title. He scorched Yale for 445 yards and led a thrilling second-half comeback. Earlier in the season he threw two touchdowns and ran for a third to knock off unbeaten Harvard, then tossed three more and ran in a fourth to stun Penn. The Ivy League honored him as player of the year. (Photograph by Beverly Schaefer, PUAD.)

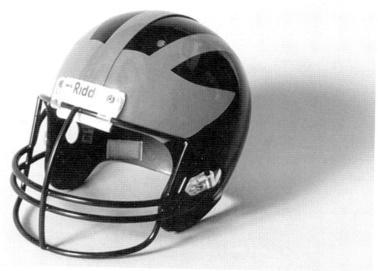

WHAT'S OLD IS NEW AGAIN. In 1880, Princeton's football team donned black jerseys with orange stripes, earning the nickname Tigers. They have worn essentially the same uniform ever since. In 1998, the team brought back Fritz Crisler's old helmet design, one usually associated with Michigan but which Crisler originally introduced at Princeton. The Tigers move forward, growing from roots planted deeply in a rich tradition. (Photograph by Beverly Schaefer, PUAD.)

PRINCETON FOOTBALL

www.arcadiapublishing.com

MAP SEARCH

Discover books about the town where you grew up, the cities where your friends and families live, the town where your parents met, or even that retirement spot you've been dreaming about. Our Web site provides history lovers with exclusive deals, advanced notification about new titles, e-mail alerts of author events, and much more.

Arcadia Publishing, the leading local history publisher in the United States, is committed to making history accessible and meaningful through publishing books that celebrate and preserve the heritage of America's people and places. Consistent with our mission to preserve history on a local level, this book was printed in South Carolina on American-made paper and manufactured entirely in the United States.

This book carries the accredited Forest Stewardship Council (FSC) label and is printed on 100 percent FSC-certified paper. Products carrying the FSC label are independently certified to assure consumers that they come from forests that are managed to meet the social, economic, and ecological needs of present and future generations.

Find Your Place in History.